Remarkable

RECLAIMING
THEIR STORIES

Women

by Alice Look

Remarkable Women:
Reclaiming Their Stories

Copyright © 2024 Alice Look,
Remarkable Women Project Inc.

Graphic Design: Evan Pittson
Copy Editor: Regan McMahon
Archival Researcher: Christine Fall

For more information about the
Remarkable Women Project
please visit:
remarkablewomenproject.org

ISBN: 979-8-35094-283-5

Table of Contents

Introduction

Every day someone asks us, "What makes a woman remarkable?"
After spending nearly three years researching some of the most remarkable women throughout history to reclaim their stories, this is what we've discovered:

>She is passionate and persistent.
>She is curious, committed and convinced she has something important to share with the world.
>She is determined and devoted to solving important problems.
>She is resilient and her passion makes a difference.

Each remarkable woman you'll meet in this book overcame tremendous adversity to succeed. They lost jobs, funding, family and friends. They made sacrifices to accomplish a variety of remarkable things.

Yet, they woke up every day, determined to keep going until they achieved their goals. They were rarely motivated by the limelight, awards, or fame. Many spent decades doing research or risking their lives without receiving fair compensation or recognition for their work.

Their names were often forgotten or ignored in history books. At best, they were footnotes in the standard telling of many of the most consequential events of the past centuries. And yet, as you will discover, their journeys are inspiring testaments that deserve to be celebrated.

To reclaim *and* share their untold stories, we've organized the book into five categories:

>Activists
>Bold Creatives
>The Firsts
>Scientists and Inventors
>Women and War

We believe all these stories will inspire you to live courageously and share their stories with your friends, family and a generation of young people who are seeking a brighter view of the world.

Jane Applegate
Editor

About the Remarkable Women Project

This book is the first in a series of books published by the Remarkable Women Project. The RWP was established in February 2023 as a non-profit educational organization dedicated to researching and telling stories about remarkable women in print, video and online.

In addition to this first book by co-founder Alice Look and edited by co-founder, Jane Applegate, we are producing a global TV series, starting with five episodes about remarkable women in Europe. Development of the EU episodes has been funded by Creative Europe. We are also writing and producing digital, online educational content for students who we hope will be inspired by learning all about these remarkable women.

The research for the book was conducted by Alice Look. She also wrote the profiles which appeared first in our Remarkable Women weekly blog. Prior to serving as executive producer of the American episodes in the Remarkable Women television series, Alice was a production executive for A&E Television Networks, a former television journalist and accomplished writer and producer.

I am a storyteller, sharing stories in print, film and online. I've produced several independent feature films, documentaries and TV series. I teach the business of film course at the Feirstein Graduate School of Cinema, Brooklyn College. This is our first book.

The book is in your hands, but the remarkable stories continue to be posted on our RWP blog nearly every week. We will never run out of stories to share. We have a database featuring close to 300 women whose accomplishments in science, technology, sports, literature and the arts deserve attention.

A final note: this book is not meant to be read cover-to-cover. Feel free to flip through the pages, reading about someone you've probably never heard of but whose story can change your life.

Jane Applegate
Co-founder
The Remarkable Women Project Inc.
October 2023

Acknowledgements

Heartfelt thanks to Evan Pittson, our talented graphic designer. His expertise and typographic ideas exceeded our original vision for this book.

Thanks to Regan McMahon, our copy editor whose sharp eye perfected these stories.

Thanks to Christine Fall, our relentless archival researcher, who tracked down and secured the rights to our photographs and illustrations.

Thanks to Lincoln Bandlow for his legal expertise in clearing and licensing our images and his invaluable connections.

Thanks to Nawal Mubin, our associate producer, for her energy and enthusiasm for this project.

Special thanks to Anita Coles, who planted the idea when she said "you should do a book."

A shout-out to Ian McGill for his support and advice for this book and our RW television concept.

Thanks to Nora Jacobson, a writer/director on the U.S. television series, for her support and creativity.

This book would not exist without the creative ideas and support of our RWP Board of Directors: Alice Look, Leslie Grossman, Joe Applegate, Jane Applegate and Judy Guillermo-Newton.

Thanks to our Advisory Board members: Hillary Cutter, whose team created our American TV series pitch deck and trailer; Jill Doyle, our Dublin-based casting consultant; Sweta Keswani, our social media and digital producer/director, Linda Denny, a respected leader in the women's business community and our newest benefactor, Brooklyn real estate expert, Charlie Pigott.

Thanks to Yvonne Russo for referring us to Evan Pittson, our talented book designer.

Finally, thanks to the amazingly talented group of European writers, producers and directors who will be producing the first five episodes of *Remarkable Women: Out of the Shadows*. Thanks to executive producer Merja Ritola, and our creative team at Greenlit Productions in Vihti, Finland for believing in our global vision for this expansive TV project.

For my mother, Soak Har "Sarah" Look,
the first remarkable woman in my life.
And for Sandy, always and forever.

Alice Look

This book is dedicated to all the remarkably
smart and supportive women in my life, but
especially to Jeanne and Julie Applegate
and my dear mother, Sherrie.

Jane Applegate

*"You may have to fight a battle
more than once to win it."*

MARGARET THATCHER

*"If you're going to change the world,
you've got to be fearless."*

FRANCES ARNOLD

Activists

Opal Lee

b. 1926

Grandmother of Juneteenth

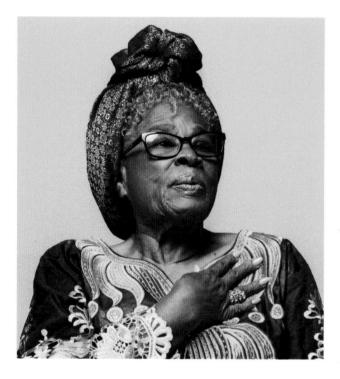

"I just knew people would notice a little old lady in tennis shoes."

For many Black Americans, June 19th has long been a bittersweet day as a celebration of freedom. Juneteenth (a combination of June and 19th) memorializes June 19, 1865, the date that federal military troops arrived in Texas to enforce the Emancipation Proclamation, which President Abraham Lincoln had issued January 1, 1863. As the last state to free its population of 250,000 enslaved people, Texas represented the legal end of slavery in the United States.

Laws can force change, but memories can have an equally powerful impact. For Opal Lee, born Opal Flake, June 19th has always been more than a date in history, because of a violent event that took place in her family on that very date. Using the ideals of Juneteenth, Lee turned a day that was a family tragedy into activism, helping thousands of people in her community. She has created a community farm and food bank, an African American historical society and has played a part in many other social welfare groups.

Opal Flake was born October 7, 1926, in Marshall, a small town in the northeastern corner of Texas. For Flake, Marshall was where she first celebrated Juneteenth. "It was just like another Christmas," she recalls. "They'd have music and food. They'd have games and food. They'd have all kinds of entertainment and food."

By the time she was 10, however, Flake's family had moved 185 miles west to Fort Worth, where there were more economic opportunities. Her mother, Mattie Broadus, worked as a cook, and her father, Otis Flake, worked for the railroad. Flake and her two brothers attended the local elementary school in their Southside neighborhood.

After suffering injuries in an accident while riding a city bus, her mother received a large monetary settlement

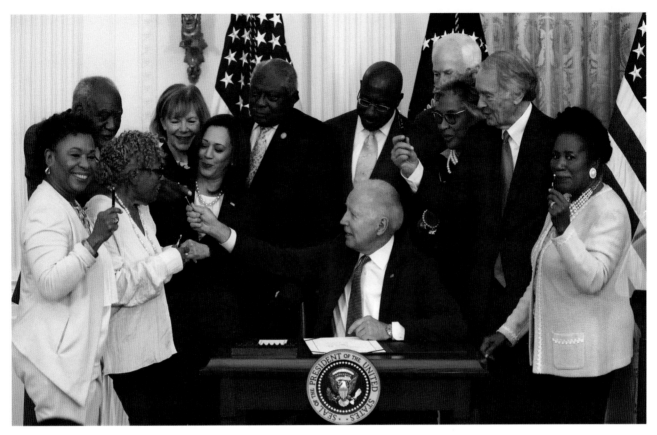

On June 17, 2021, with Lee present (second from right), President Joe Biden signs the bill making Juneteenth a Federal holiday.

that enabled the family to purchase a home on East Annie Street, making them the first Black family in a mostly white neighborhood.

On June 19, 1939, a few days after moving in, a mob of 500 white residents swarmed the property, smashing windows and breaking into the house. They set a fire that destroyed everything. "Those people went ahead," Flake remembers, "and pulled our furniture and burned it. They did despicable things."

Terrified, the family watched as the police, outnumbered and overwhelmed by the mob, were unable to stop the violence. A frightened Flake remembers her father rushing home from his job with a gun only to get a warning.

"Police told him, 'If you bust a cap, we will let this mob have you,'" she recalls. "Our parents sent us to friends several blocks away, and they left on the cusp of darkness." The family never spoke again about the horrific incident, but Flake carried the memories of it long into her adult life. "The fact that it happened on the 19th day of June has spurred me to make people understand that Juneteenth is not just a festival," she said.

The family relocated to another street in the Southside, and Lee attended I.M. Terrell High, the city's first all-Black high school. When she graduated at 16, Flake's parents wanted her to go onto college, but Flake had other ideas. She married Joe Roland, her high school sweetheart, and they started a family. Five years and four children later, the marriage was over. Flake faced a harsh reality: in 1948, a Black female single parent in Texas with a high school diploma was destined for poverty.

Taking her parents' earlier advice, Flake enrolled at Wiley College back in Marshall. During the week, her mother would watch her kids while she took classes and worked at the college bookstore. On the weekends, she was back in Fort Worth, working an assortment of jobs to make ends meet and pay for her education.

Three-and-a-half years later, Lee graduated with a teaching degree in elementary education. Returning to Fort Worth, she landed a teaching job, but the pay was $2,000 a year—the equivalent of about $23,000 today—hardly enough to support a family of five. So Flake took a second job as a maid for Convair, an aerospace manufacturer and

one of the biggest local employers. For years she clocked a 16-hour day. "I'd go [to teach] at 8 AM, get off at 3 PM," Flake says. "There'd be a car waiting for me and I'd check in at 4 and get off at 12."

Flake's teaching career spanned the civil rights era, a time when segregation gave way to integration in the class-rooms and society. The world was changing dramatically, but raising her children was the priority. In 1967, after marry-ing her second husband, Dale Lee, the principal of one of the city's elementary schools, Lee got a master's degree in counseling and guidance. It took her career in a new direc-tion. She became a home school counselor, visiting parents and getting them social services when they needed them, so that their kids could continue to attend school.

When Lee retired in 1977, she began her second career as a community activist. Over the next four decades, she helped save a local food bank from going under. Today, the Community Food Bank serves 500 families a week in Fort Worth. She also created Opal's Farm, a five acre farm that grows fresh produce and provides jobs, volunteer opportu-nities and education to the community.

When she helped found the Tarrant County Black Historical and Genealogical Society to preserve local Black history, one of her roles was organizing the annual Juneteenth celebration. Nearly every year she would lead a two-and-a-half-mile walk on June 19th, representing the two-and-a-half years it took for word of the Emancipation Proclamation to reach Texas. As more and more states began recognizing the day, Lee began pushing lawmakers to make it a national day of remembrance.

In September 2016, Lee felt she had to "go big... and double down" on her mission. Her goal was to walk 1,400 miles between Fort Worth and Washington, D.C. to meet President Barack Obama and make her case for Juneteenth. Walking 10 miles a day through major cities including Denver, Chicago, Colorado Springs, Atlanta and St. Louis, she arrived in Washington five months later in January 2017.

"I just knew people would notice a little old lady in tennis shoes," she said, "and they did." Lee, who is now known as the "grandmother of Juneteenth," didn't get to plead her case with the president, but the walk energized the campaign. Along the way, media attention resulted in more than 1.5 million signatures in an online petition.

It would take four more years of advocacy, but on June 17, 2021, with Opal Lee present in the Oval Office, Presi-dent Joe Biden signed the bill making Juneteenth a federal holiday. Lee received the first pen used to sign the docu-ment and received a standing ovation during the ceremony. In 2022, Lee's lifelong mission was recognized in a letter nominating her for the Nobel Peace Prize: "The celebration of Juneteenth became for her not just a day to celebrate the freeing of enslaved people in Texas but the recognition of the need to uphold the freedoms that African Americans gained and a call to fight... for equality for all humans."

To mark the holiday on June 19th, 2023, more than 2000 people joined Opal Lee on a march through the Fort Worth neighborhood where the National Juneteenth Museum is being planned.

Eleven year old Zebiyah Fields leads the Juneteenth celebration in Flint, Michigan, 2018.

Dorothy Harrison Eustis

1886–1946

Founder, *The Seeing Eye*

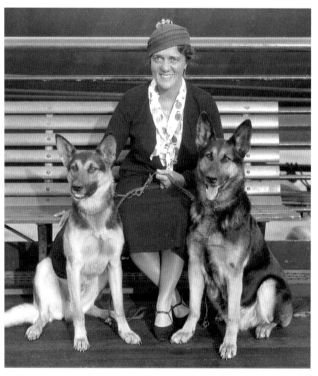

Dorothy Harrison Eustis with Parole and Nancy, two of the first dogs trained at The Seeing Eye in 1933.

"To think that one small dog could stand for so much in the life of a human being..."

Before 1929, there was no such thing as guide dogs for the blind population in the United States. Living with blindness meant relying on others and limited independence. Even the white cane, now a standard device used by the blind for mobility and identifying obstacles, had not been invented yet.

But that year, a revolution began with the founding of The Seeing Eye, the first organization in the country to train dogs specifically to become "the eyes" of blind humans, in essence giving people who could not see a chance to live a more independent life.

Dorothy Harrison Eustis, born May 30, 1886, was the founder of The Seeing Eye. She knew more about cows than dogs when she began breeding and training dogs. Eustis and her first husband, Walter Woods, had spent nearly a decade working with the New York State Agricultural Department to develop an experimental breeding program for cattle on their Hoosick Falls farm. During that time, she would acquire Hans, a German Shepherd that would become an inspiration as she developed guide dog training.

By 1921, Eustis had remarried after Woods' death. She and her new husband relocated to Europe to open Fortunate Fields, a dog-breeding operation in Vevey, Switzerland. The German Shepherds they bred were also being trained to work with the Swiss Army, customs officers and the police. Known as a highly intelligent breed, the Shepherds were excellent at tracking and finding lost and missing persons.

For years, Eustis had heard about a dog-training program in Potsdam, Germany, where canines were helping soldiers who had lost their sight in World War I regain their independence and confidence. Intrigued but skeptical, she

and her husband went to visit the program in 1927. As she toured the program, meeting the dogs and their human partners, she was astonished by what a two-species team could do together. The visit was a life-changing experience, not only for Eustis but for the tens of thousands of blind people who would benefit from the organization she would ultimately create.

In passionate detail, Eustis wrote about the German guide dog program for *The Saturday Evening Post*, one of the most popular magazines of the time. The article prompted an avalanche of mail from people who were interested in the program. One letter came from 19-year-old Morris Frank. At age six, he had lost sight in his right eye in a horseback riding accident. At 16, a boxing match blinded his left eye. With years of life still ahead of him, Frank was enthusiastic about finding a canine companion to help him overcome his disability.

Frank immediately wrote to Eustis: "Is what you say really true? If so, I want one of those dogs! And I am not alone. Thousands of blind like me abhor being dependent on others. Help me and I will help them. Train me and I will bring back my dog and show people here how a blind man can be absolutely on his own."

Eustis wasn't thinking of training guide dogs for the blind, but moved by Frank's situation, she invited him to visit her program in Switzerland. By the time he arrived in April 1929, she was teaching two of her dogs the commands she had seen at the Potsdam program. Frank spent the next several weeks learning how to navigate the small town of Vevey with his trainers and Buddy, a young female German Shepherd. Their training was completed by June, and Frank and Buddy headed home.

Arriving in New York City, they were greeted by a crowd of reporters who clamored for a demonstration. Without any knowledge of the city, its traffic, crowds and noise, Frank was unsure whether Buddy could handle the new environment. But the pair navigated the press scrum and then crossed busy West Street without incident. "Success," Frank telegrammed Eustis. Buddy, he told reporters, was "his declaration of independence."

Frank kept his word about promoting guide dogs, and he and Buddy began to speak at events around the country. The positive response led Eustis and Frank to co-found The Seeing Eye in January 1929. It was America's first guide dog training and breeding organization. First located in Frank's hometown of Nashville, it eventually found a permanent home in Morristown, New Jersey.

Frank became its managing director and devoted his life to promoting guide dogs for the blind. He advocated for guide dogs to be given equal access to public places, and his efforts played a role in the passage of the Americans with Disabilities Act (ADA) in 1990. He also pioneered guide dogs on airplanes and trains. In one of their final trips in May 1938, Buddy became the first guide dog to fly on a commercial airliner—flying coach on United Airlines from Chicago to Newark, New Jersey.

Dorothy Harrison Eustis, The Seeing Eye's first president, shaped the guide dog field in the United States. Her remarkable background as a dog breeder and trainer, combined with her belief in what was then an unproven approach, bettered the lives of generations of visually impaired people. In the 1930s, as The Seeing Eye was getting off the ground, she sent dogs and trainers to Italy, Great Britain, and France so those countries could establish their own guide dog schools. The training curriculum she created set the standard for guide dog schools that opened in other parts of the United States as well.

As guide dogs became more commonplace and accepted, the image of the blind underwent a positive change in popular culture. In 1979, the United States Postal Service issued "The Seeing Eye" stamp to mark the 50th anniversary of organization. In 1984, Disney released "Love Leads the Way," a movie about Morris and Eustis and the creation of the non-profit. And in 2020, the seeing eye dog became the official dog of New Jersey.

The Seeing Eye is still very much in existence. In 2023, it graduated its 18,000th human-canine team. Since that first class of German Shepherds that Eustis helped train, today Labrador retrievers, golden retrievers and lab/golden mixes are also trained to be service animals.

Guide dog training now includes new technologies that weren't around in 1929: automatic doors, elevators, ramps and hybrid and electric cars, which present new challenges because they are quieter and harder for people and dogs to detect.

No longer the only guide dog organization in the U.S., The Seeing Eye remains a pioneer in the field, thanks to Dorothy Harrison Eustis.

Barbara Gittings

1932–2007

LGBTQ+ Activist

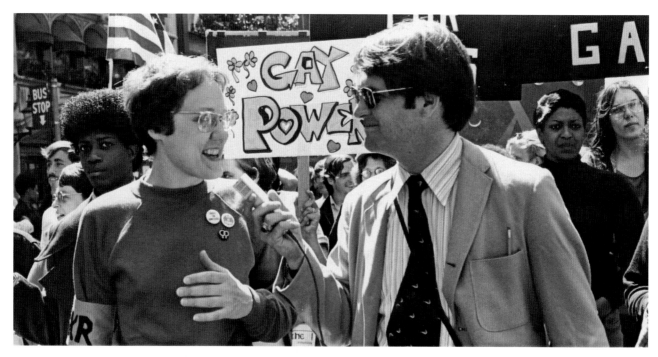

Gittings with a reporter from KYW Radio at the Philadelphia Gay Pride rally, 1972.

"Equality means more than passing laws. The struggle is really won in the hearts and minds of the community, where it really counts."

In 1950s America, there was no such thing as a gay rights movement. LGBTQ+ wasn't a shorthand term for the non-heterosexual population. And because homosexuality was a crime in some states and considered a perversion by many in the medical community, gay men and lesbians lived double lives hiding their identities. It was not only dangerous to come out, but anyone who did, risked career and social suicide.

Barbara Gittings, however, was one of the very few women who had the courage to defy societal norms and family disapproval. She not only declared her sexuality but also helped build a movement to gain equal rights and respect for non-heterosexuals. But before she could

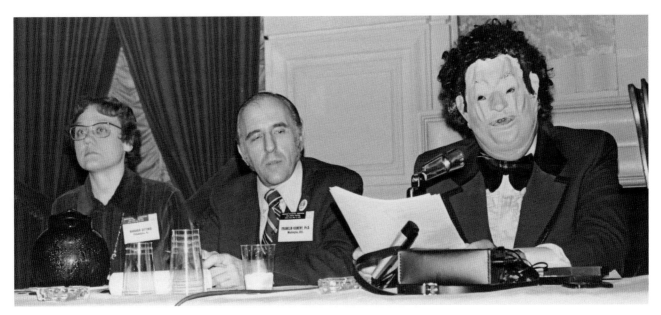

Gittings, gay rights activist Frank Kameny and Dr. "H. Anonymous" at the American Psychiatric Association meeting in Dallas, TX, May 1972.

create a campaign, she had to take the first step in her own personal journey.

One of three children, Barbara Gittings was born in Vienna, Austria, July 31, 1932. Her father, John Sterett Gittings, was an American diplomat posted in Europe. The family lived abroad until the start of World War II, when they headed for the safety of the United States, settling in Wilmington, Delaware.

During adolescence, Gittings began to have stirrings about her sexual identity, although she didn't know the terms "homosexual" or "lesbian." At 16, when one of her teachers told her she was rejected by the National Honor Society most likely because of "homosexual inclinations," it further fueled her curiosity about herself and why her feelings for other girls were considered unacceptable and taboo.

After graduating from high school, she headed for Northwestern University in 1949 to study drama. But schoolwork quickly took a backseat when learning about homosexuality became an obsession. There were no organizations or support groups, so Gittings scoured the libraries. The information in psychology books was judgmental and "dismal," she said. Homosexuals were "perverts," "sick," or "deviants." There was nothing written by a homosexual, and in an interview in 2001, she recalled how depressing it was to read what she was uncovering.

At the end of her freshman year, Gittings dropped out of college. She returned home but couldn't tell her family

about her feelings and frustrations. When her father found a copy of the classic lesbian novel *The Well of Loneliness* in her bedroom, he was too shocked to talk to her about it. Instead, he wrote a letter, telling her the book was immoral and that she had to destroy it.

Gittings knew a new life beckoned. She moved to Philadelphia in 1950 and supported herself by working at clerical jobs. She met gays and lesbians in San Francisco and New York City throughout the decade, and together they formed a community of mutual support.

In 1958, after visiting the West Coast founders of The Daughters of Bilitis, a feminist lesbian organization, Gittings organized a New York City chapter of the group. In 1963, she became the editor of the organization's newsletter, *The Ladder*, and used it as a platform for advocacy. She put photos of real-life gay couples on the cover, covered protests, printed interviews with experts and editorialized on discriminatory practices and policies. The militant tone clashed with the founders of the newsletter and she was fired.

Undaunted, Gittings took her activism to the streets. Between 1965 and 1969, she organized demonstrations in front of the White House, Pentagon and State Department to protest the government's discriminatory hiring policies against homosexuals. Gittings' picket sign with the words "Sexual preference is irrelevant to federal employment," is in the Smithsonian today. For years, she and fellow gay activist Frank Kameny held "Annual Reminder" protests

Randy Wicker and Gittings at Reminder Day Protest, Philadelphia. July 4, 1966.

on July Fourth at Independence Hall in Philadelphia to remind the public that homosexuals did not have equal rights. In 1970, the year after the Stonewall Uprising in New York City, the Annual Reminder was suspended and protesters were urged to take part in a march in the city to commemorate the riot. More than 10,000 people took part in that march, a resounding affirmation of the strength of the growing gay rights movement. It launched the tradition of a Pride Parade, an annual event now celebrated in communities around the world.

"We can't get anywhere if we're a hidden people," Gittings declared in an August 2005 interview with *Philadelphia Gay News*, adding, "I've always promoted visibility as the key to our success." Gittings also borrowed tactics from the civil rights movement. If "black is beautiful," she thought, it's also possible that "gay is good."

In the 1970s, Gittings took on one of the most powerful voices in the medical community, the American Psychiatric Association (APA), which had declared homosexuality a "perversion and mental illness." After gay activists stormed the APA's annual meetings for two years, Gittings and Kameny were invited to speak at its 1972 convention.

They created a photo exhibit of healthy and happy gay couples to counter the association's claim that gay people were tormented, miserable and needed to be "cured." The photos were taken by Gittings' partner, photojournalist Kay Tobin Lahusen.

At a panel discussion, Gittings and Kearney introduced a surprise guest, gay psychiatrist Dr. John E. Fryer who appeared in disguise. Wearing a mask and a clown costume, and with his voice distorted through a special microphone, he introduced himself as "Dr. H. Anonymous." Declaring "I am a homosexual. I am a psychiatrist," he went on to talk about the tortured double life he led in a profession that scorned homosexuals. The problem, Dr. Anonymous said, was not homosexuals but toxic homophobia. The association's "treatment" of shock therapy, lobotomies and institutionalization was damaging and wrong. Furthermore, Dr. Anonymous claimed, there were many more psychiatrists who were gay and leading double lives. A year later, the APA removed homosexuality from its list of mental disorders.

As the gay rights movement started building steam throughout the 1980s and '90s, Gittings played a major role in the creation of many consequential organizations, including the National Gay and Lesbian Task Force, known today as the National LGBTQ Task Force.

While Gittings was not a librarian, she always had a soft spot for the resources and support she found in libraries as a teenager in search of her identity. When the American Library Association (ALA) started its Gay Task Force in 1970, today known as the Rainbow Round Table, she became its coordinator. The group was formed to provide support for gay librarians and increase the number of positive books and materials about homosexuals in libraries. In 1999, in honor of her contributions, the ALA awarded her a lifetime membership in the organization and created the annual Stonewall Book Award and the Barbara Gittings Literature Award for works of fiction that exhibit "exceptional merit relating to the LGBTQIA+ experience."

Well into her 60s, Gittings remained a dedicated activist. When she and her partner, Kay Lahusen, moved into a senior assisted living facility in 1997, they were the first same-sex couple to come out on the cover of the facility's newsletter. After a long battle with breast cancer, Gittings died on February 18, 2007.

Pride celebration in Syndey, Australia, 2019.

Mary Tape & Mamie Tape

1857–1934 1876–1972

Civil Rights Activists

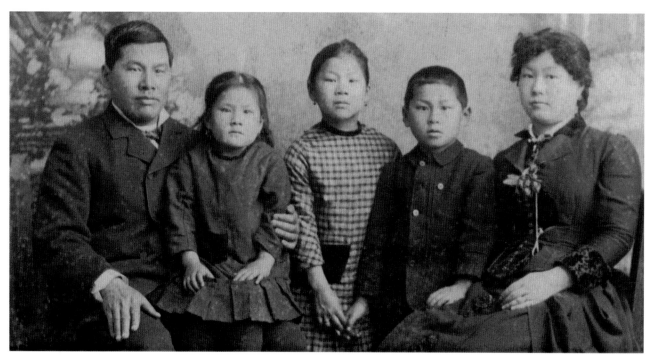

The Tape family (from L to R): Joseph, Emily, Mamie, Frank and Mary. San Franciso, 1884.

"Is it a disgrace to be born a Chinese? ...What right have you to bar my children out of school because she is of Chinese descent?"

Mamie Tape was eight years old when she made history. In 1884, her parents, Mary and Joseph Tape, sued a California school system for discrimination after they refused to admit their daughter because she was Chinese. They won the case, but it was a bittersweet victory.

On a bright September morning in 1884, Mamie Tape was ready for her first day at Spring Valley Primary School in San Francisco. Wearing a checked dress, her hair neatly braided and tied with a ribbon, she was excited to be joining her friends at the five-room school just a few blocks away from her home. With her mother, Mary, Mamie set off with high hopes.

But the principal of Spring Valley, 44-year-old Jenny Hurley, had other ideas. Hurley refused to allow Mamie

inside the school. Spring Valley was for white children only, she told them, and even though Mamie had been born in San Francisco and state law entitled all children in California to a public education, the city laws did not.

Mary and her husband, Joseph Tape, did not anticipate that Mamie would be turned away. They were mild-mannered people who kept a low profile, but they were not going to accept this decision quietly. As recent immigrants from China, each had overcome incredible obstacles to survive and make a life in the United States. They were not about to give up without a fight.

Joseph Tape had come to the U.S. 20 years earlier as a young boy. His name was then Jeu Dip. He had been born in 1852 in Guangdong province, an area of southern China that was the epicenter of migration to the U.S. starting with the California Gold Rush in 1848. Famine, poverty, war, and fantasies of wealth in Gold Mountain, as they called western regions of North America and particularly California, led thousands of Chinese men to leave China.

Determined and clever, Jeu Dip wanted in on that American dream. When he arrived in San Francisco, there was no Gold Mountain, but there were lots of opportunities for work, which he took advantage of over the next decade. He learned English well enough to become a translator, an immigration broker and successful small businessman. Within 10 years he had become well regarded and respected in both the Chinese and white communities.

Mamie's mother, Mary, had come to the U.S. as a young girl of 11, also with no family and no recorded Chinese name. She ended up living in a home run by a Protestant missionary and was given an English name: Mary McGladery, which was actually the name of one of the women who ran the Ladies Protection and Relief Society. Like her future husband, Mary became literate in English and adapted well to Western culture.

In 1875, Mary and Jeu Dip met for the first time. Since they spoke different Chinese dialects, they courted in English. They were likely the first Chinese Americans who felt more comfortable in their adopted countries than where they were born. At their wedding, Jeu Dip became Joseph Tape, an Anglicization of his original name. A year later, Mamie, the first of their four children was born.

The Chinese consulate was one of Joseph Tape's best clients, and it was there he first asked for help with getting Mamie into Spring Valley Primary. The consulate's white attorney filed a protest with the San Francisco school board. Tape also hired a lawyer, William Gibson, to file a lawsuit. Gibson argued that barring Mamie from the school violated the state's school law and the Fourteenth Amendment that guaranteed equal protection and due process to everyone.

By the end of 1884, the case of *Tape v. Hurley* was one of the hot button issues in the city, adding to the anti-Chinese sentiment that had been building before the passage of the 1882 Chinese Exclusion Act. Besides suspending the immigration of Chinese laborers, the act banned all Chinese living in the U.S. from becoming naturalized citizens. More significantly, it stands out to this day as the only American law to single out a specific group for exclusion.

In January 1885, despite the hostile climate, the Superior Court of California ruled in Mamie's favor. When the school board appealed, the state Supreme Court upheld the ruling. Mamie had won the case, but the battle wasn't over.

Anticipating that they might lose, the school board had put pressure on the California state legislature to pass a law creating separate schools for "children of Chinese and Mongolian descent." Two months after the ruling in Mamie's favor, San Francisco announced plans for a Chinese Primary School near the city's Chinatown. It would occupy the top two floors above a grocery store.

In April 1885, four months after the ruling, Mamie went back to Spring Valley, this time with both her parents and two lawyers. Jenny Hurley once again turned Mamie away, claiming she didn't have the required vaccination documents. And, she said, the school was full, but Mamie could be put on a waiting list. That evening, the superintendent of the San Francisco public schools spoke publicly about his intention to keep Mamie from attending Spring Valley and pushed for a quick opening of the Chinese school. In essence, he flouted the legal ruling.

Mary Tape, in a letter to the *Daily Alta California* was outraged. "Will you please tell me! Is it a disgrace to be Born a Chinese? Didn't God make us all!!!… Do you call that a Christian act to compel my little children to go so far to a school that is made in purpose for them." Why, she asked, is Mamie being "persecuted… because she is of Chinese descent?"

Mary vowed, "Mamie Tape will never attend any of the Chinese schools of your making! Never!!" However,

AN INDIGNANT MOTHER

She Takes the San Francisco Board of Education to Task Sharply

[San Francisco Letter.]

The board of education of San Francisco is in a bad predicament owing to a recent judicial decision, in accordance with which the Chinese of that city may demand education for their children at the public expense. It was determined by the board that the Chinese children should have a separate school-house, but when the building was provided no pupils were to be found except a little 9-year-old girl and her parents insisted that she should attend one of the public schools near her home. The strife over the matter called forth the following letter from an indignant mother:

No. 1,769 GREEN STREET, SAN FRANCISCO, April 8, 1885.—To THE BOARD OF EDUCATION—DEAR SIRS: I see that you are going to make all sorts of excuses to keep my child out of the public schools. Dear sirs, Will you please to tell me! Is it a disgrace to be Born a Chinese? Didn't God make us !!! What right! have you to bar my children out of the school because she is a Chinese Descend. They is no other worldly reason that you could keep her out, except that. I suppose, you all go the churches on Sundays! Do you call that a Christian act to compel my little children to go so far to a school that is made in purpose for them. My children don't dress like the other Chinese. They look just as phunny among them as the Chinese dress in Chinese look amongst you Caucasians. Besides, If I had any wish to send them to a Chinese school I could have sent them two years ago without going to all this trouble. You have expended a lot of public money foolishly, all because of a one poor little child. Her playmates is all Caucasians ever since she could toddle around. If she is good enough to play with them! Then is she not good enough to be in the same room and study with them? You had better come and see for yourselves. See if the Tape's is not the same as other Caucasians, except in features. It seems no matter how a Chinese may live and dress so long as you know they Chinese. Then they are hated as one. There is not any right or justice for them.

You have seen my husband and child. You told him it wasn't Mamie Tape you object to. If it were not Mamie Tape you object to, why didn't you let her attend the school nearest her home? Instead of first making one pretense Then another pretense of some kind to keep her out? it seems to me Mr. Moulder has a grudge against this Eight-year-old Mamie Tape. I know they is no other child I mean Chinese child! care to go to your public Chinese school. May you Mr. Moulder, never be persecuted like the way you have persecuted little Mamie Tape. Mamie Tape will never attend any of the Chinese schools of your making! Never!!! I will let the world see sir What justice there is When it is govern by the Race prejudice men! Just because she is of the Chinese dscend, not because she don't dress like you because she does. Just because she is descended of Chinese parents I guess she is more of a American than a good many of you is going to prevent her being Educated.

MRS. M. TAPE

the following week, both Mamie and her younger brother, Frank, enrolled at the Chinese Primary School, which they would continue to attend for several more years until the family moved out of the city.

It's significant to note that Mamie Tape's legal victory took place 70 years before *Brown v. Board of Education*, the landmark 1954 case that declared school segregation unconstitutional. Although Mamie never got to attend Spring Valley Primary, *Tape v. Hurley* changed the political and cultural climate in the city. In time, Chinese children began attending white schools in San Francisco. It took many more decades—until 1947—before the state law that created separate schools was finally overturned in California.

Even though the courts ruled that Mamie Tape had a right to attend San Francisco public schools, the Board of Education refused to admit her. Here is Mary Tape's letter protesting their refusal published in the *Daily Alta California* in 1885.

THE
Chinese Must Go!

Mayor Weisbach

Has called a MASS MEETING for
this (Saturday) evening at
7:30 o'clock

AT ALPHA OPERA HOUSE.

To consider the Chinese question.

TURN OUT.

The Chinese Exclusion Act, passed in 1882, encouraged racist attitudes towards Chinese Americans.
This flier was posted in Tacoma, Washington in 1885.

Anna Jarvis

1864–1948

Creator of Mother's Day

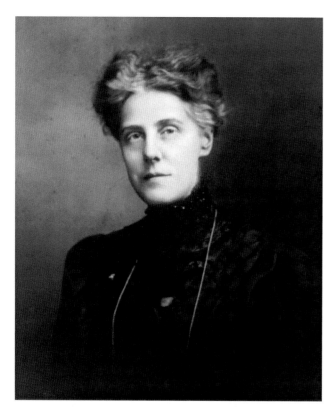

"Any mother would rather have a line of the worst scribble from her son or daughter than any fancy greeting card."

Anna Jarvis, who never married and never had children, created Mother's Day in the United States in memory of her mother. Years later, she was so upset by how commercial she felt the day had become that she campaigned to abolish the holiday.

In 1858, Anna's mother, Ann Reeves Jarvis, was an early social activist in her Appalachian town of Grafton, West Virginia. The mother of 13 children of whom only four survived, Reeves Jarvis was appalled at the high infant and child mortality rate in her community. With the blessing of local doctors, she organized Mother's Day Work Clubs to help educate mothers about hygiene, sanitation, and disease. She taught them to boil water before drinking, to quarantine family members to keep disease from spreading into the community and provided medicines and supplies to the sick and poor.

During the U.S. Civil War, Reeves Jarvis vowed that the clubs would rise above Union and Confederate differences and would tend to the wounded of both sides. She wrote, "friendship and goodwill should obtain for the duration and aftermath of the war… we are composed of the Blue and the Gray."

True to her word, after the war ended, she organized a Mothers' Friendship Day for mothers and neighbors to promote reconciliation, an event that continued for years in her community.

Reeves Jarvis also taught Sunday school, and one prayer made a profound impact on her 12-year-old daughter, Anna. At the end of a "Mothers of the Bible" lesson, she said, "I hope and pray that someone, someday will found a memorial Mother's Day to commemorate the mother for the matchless service she renders to humanity in every

field of life. She deserves it."

At her mother's funeral in 1905, Anna Jarvis promised, "By the grace of God, you shall have that Mother's Day." A year later, on the anniversary of her mother's death, Jarvis held a memorial where she praised her mother's life of devotion to community service and family.

She followed that up with a massive three-year letter writing campaign to state governors, newspaper editors, and prominent figures, including Mark Twain and ex-President Theodore Roosevelt. She made speeches and visits to politicians, church groups, anyone who would listen to her idea for a Mother's Day holiday.

Jarvis' first major support came from John Wannamaker, the wealthy department store merchant. In 1908, the first Mother's Day ceremonies were held at his store in Philadelphia and at St. Andrew's Episcopal Church in Grafton, where Reeves Jarvis' funeral had been held.

The Mother's Day movement took off from there. Within a year, 45 states were celebrating Mother's Day. In 1914, President Woodrow Wilson signed a proclamation that the second Sunday in May would become a holiday called Mother's Day.

In 1915, the popular holiday crossed the border into Canada. Today, hundreds of countries around the globe have their own Mother's Day, which are sometimes held on other dates.

Jarvis' idea of honoring mothers was a simple one—attending church services and writing a heartfelt letter expressing love and gratitude for a mother's sacrifices and devotion. She chose a white carnation, her mother's favorite flower, to wear as a symbol of the holiday.

For the first few years, Jarvis worked with the floral industry to promote Mother's Day, but when the cost of carnations, candy and cards spiraled every May, she became angry. The sentimental intent of Mother's Day was being ruined by commercialism and profit, she said. She threatened to sue the industry and tried unsuccessfully to trademark the image of the carnation.

In response, the Florist Telegraph Delivery (FTD) Association offered her a commission on Mother's Day sales, which further enraged Jarvis. In 1922, she urged people to boycott buying flowers. She wrote, "What will you do to rout the charlatans, bandits, pirates, racketeers, kidnappers and other termites that would undermine with their greed one of the finest, truest and noblest of celebrations?"

In 1923, she targeted the candy industry, crashing a retail confection convention to protest their Mother's Day sales. Jarvis even opposed using Mother's Day as an opportunity to help charities that supported poor and deserving women. When the American War Mothers held a fundraiser on Mother's Day at their convention in 1925, Jarvis stormed the event and was arrested for disturbing the peace. The holiday was dragged into the American suffrage movement when people on both sides of the issue began debating the role of mothers in society.

There were no limits to Jarvis' opposition. When the U.S. Postal Service issued a commemorative Mother's Day stamp in 1934 featuring a reproduction of *Whistler's Mother* with a vase of carnations, she saw it as a blatant ad for the floral industry. In 1935, she even accused First Lady Eleanor Roosevelt of "crafty plotting" for using Mother's Day to raise funds to help combat high maternal and child mortality rates. Ironically, those were the same issues that her own mother worked on in her lifetime.

Jarvis copyrighted the phrase "Second Sunday in May, Mother's Day" and threatened to sue anyone who used it. At one point in 1944, a *Newsweek* article claimed she had 33 pending lawsuits. Finally, when nothing seemed to stop the tide of marketing, Jarvis publicly disowned the holiday and went door to door to get signatures to abolish it. She and her sister spent their savings trying to undo the holiday they had so passionately created.

Anna Jarvis died at 84 in 1948 at a sanitorium in West Chester, Pennsylvania. The Anna Jarvis House, her childhood home in Grafton, West Virginia, is listed on the National Register of Historic Places.

Industry experts say Americans spent $35.7 billion, or $274 per mother on Mother's Day in 2023.

"I think success has no rules, but you can learn a great deal from failure."

JEAN KERR

Playwright

Bold Creatives

Ann Lowe

1898–1981

Fashion Designer

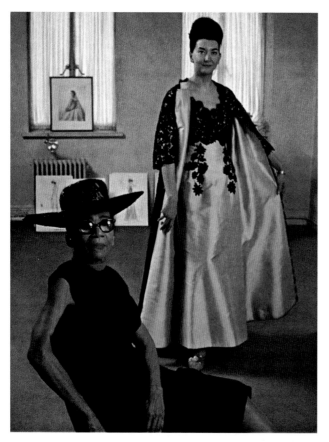

Ann Lowe in her fashion salon with model Judith Palmer wearing a Lowe design of Italian silk and re-embroidered black lace. 1966.

"I love my clothes and I'm particular about who wears them... I sew for the families of the Social Register."

In 1953, Jacqueline Bouvier and John Kennedy were the most glamorous couple in America. Jackie was a 24-year-old debutante turned photojournalist, and Kennedy, at 36, was a former war hero and senator from Massachusetts. Young, beautiful and wealthy, they made the cover of *Life* magazine, which celebrated their romance.

Their marriage on September 6, 1953, in Newport, Rhode Island, was a lavish affair on the level of a royal wedding. Upwards of 3,000 spectators lined the streets around St. Mary's Church for a glimpse of the couple, while inside 600 guests oohed and aahed as Jackie walked down the aisle in a stunning wedding dress that almost stole the show.

It was the wedding of the year. Hundreds of photographs left no detail uncovered, except for one key tidbit of information about The Dress. Who was the designer behind the gorgeous bridal gown that was created from 50 yards of ivory silk taffeta complete with flounces and embroidery? Only one news organization, *The Washington Post*, gave Ann Lowe credit as the designer for the future First Lady's wedding gown. Had she been given credit for the bridal gown of the year, Lowe would have been swamped with orders for "Jackie's dress," ensuring financial security rather than the destitution that ended her final years. Instead, Lowe remained invisible as "society's best kept secret," even as millions admired her most significant creation.

Ann Lowe was born in rural Alabama, December 14, 1898, into an African American family of talented dressmakers. Her mother, Janie Cole Lowe, and grandmother, Georgia Thompkins, were seamstresses who ran a successful business making clothes for a white clientele in Montgomery, Alabama. Lowe learned how to sew from them, and at 16, when her mother died, she took over the

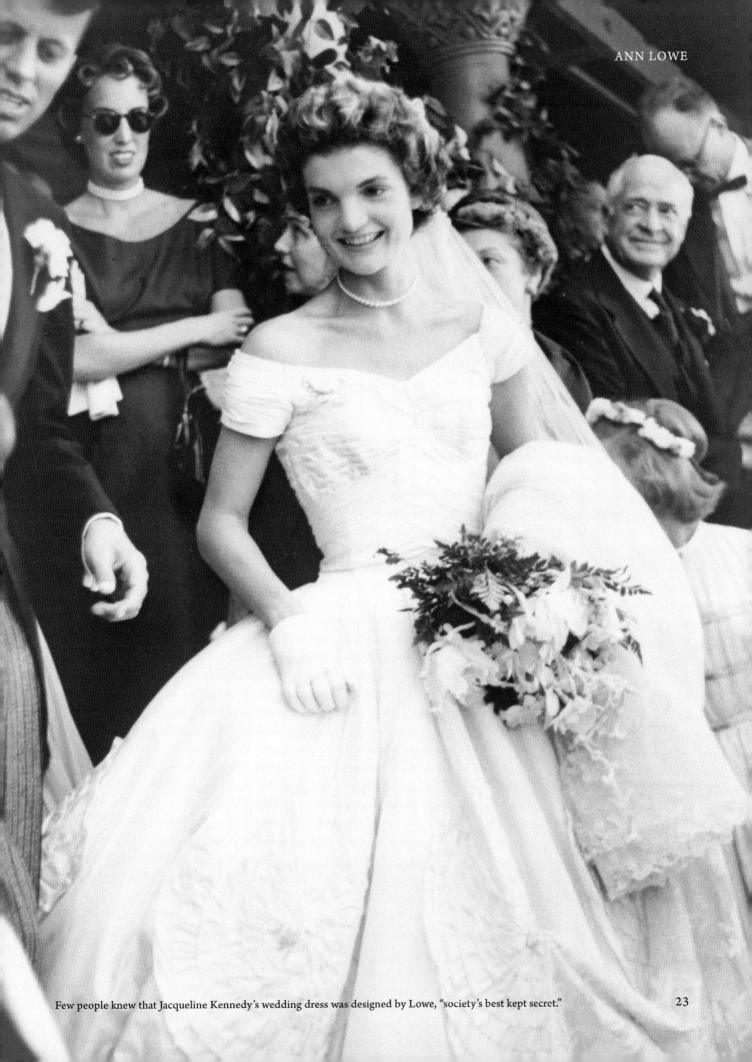

ANN LOWE

Few people knew that Jacqueline Kennedy's wedding dress was designed by Lowe, "society's best kept secret."

23

business. Her very first job was to finish four dresses that her mother had been working on for a New Year's Eve ball. One of them was for the wife of Alabama's governor. She made the deadline, and for the next few years she kept the business going as she honed her dressmaking skills. She also married her first husband, Lee Cone, during this time.

In April 1917, Lowe left Tampa, Florida, where she had been a family's live-in seamstress, to start classes at the S.T. Taylor Design School in New York City. When she arrived, she wasn't allowed to take classes with the rest of the students because the director said they refused to have an African American in the class. Undaunted, Lowe persuaded the director to let her stay and she took classes alone in a separate room, finishing her courses ahead of schedule.

Returning to Tampa, Lowe opened the Annie Cone boutique, specializing in making ball gowns and formal wear. Business was so good she had to hire a staff of 18 seamstresses to keep up with the demand. By 1920, Lowe was divorced and had a second husband, Caleb West. Her new marriage and boutique business flourished and nourished Lowe's bigger ambitions for a salon in New York City.

By 1947, after more than three decades as a dress designer, Lowe had become a master couturier. When actress Olivia de Haviland accepted the Oscar that year for best actress in the movie *To Each His Own*, she was wearing an aqua strapless hand-painted floral Ann Lowe design from the house of Chez Sonia.

It wasn't until the 1950s, more than two decades after arriving in New York City, that Lowe, with business partner Grace Stelhi, was able to finally fulfill her dream. Ann Lowe Inc. at 667 Madison Avenue became the address where upper crust society matrons named duPont, Rockefeller and Auchincloss and many others came for fittings for their fanciest evening wear.

She was the first African American to have a fashion studio on Madison Avenue. Over her career she would have several other custom design stores on Madison and Lexington Avenues and her reputation would increase with each one. Even Christian Dior was reportedly impressed by her technique, creativity and craftsmanship, when he first came across her gowns.

In an interview in *Ebony* magazine in 1966, Lowe confessed to being a snob and said, "I love my clothes and I'm particular about who wears them. I'm not interested in sewing for café society or social climbers. I do not cater to Mary and Sue. I sew for the families of the Social Register." In another interview for *The Mike Douglas Show*, she said one of the greatest satisfactions her career had brought her

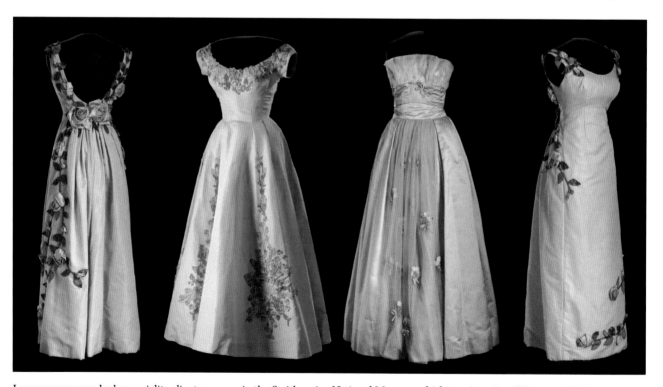

Lowe gowns worn by her socialite clients are now in the Smithsonian National Museum of African American History and Culture.

was she had been able to prove "that a Negro can become a major dress designer."

One of Lowe's best clients was Janet Bouvier, who asked Lowe to make a dress for her wedding to her second husband, Hugh Auchincloss, in 1942. Eleven years later, she asked Lowe to do the same for her oldest daughter, Jacqueline.

Lowe knew this was the biggest commission of her life. Besides the wedding gown, Lowe was also making all the bridesmaid dresses. But 10 days before the wedding, a pipe burst in her studio and the flood ruined almost every dress she had been working on for the past two months. Lowe had to start all over, ordering new material at a cost she absorbed, and hiring extra seamstresses to work round the clock. Lowe never told her client about the accident and ended up losing $2,200 on the entire order.

Taking the train to Newport on the day of the wedding, Lowe arrived at the Auchincloss mansion only to be told to go round to the servants' entrance because she was Black. Lowe replied that she would "take the dresses back" unless she could enter through the front door.

While the dress Lowe created is now considered a classic for its chic timeless elegance, Jackie Kennedy reportedly wasn't thrilled with the design. With its off the shoulder, sweetheart neckline and bouffant skirt with wax flowers, Jackie thought it was over the top. She compared the skirt to a lampshade. Jackie was a fashionista and she wanted something more streamlined with a "latest from Paris" vibe.

Sadly, Lowe's business skills failed to match her mastery of fabric, thread, color and design. She often underpriced her designs and was frequently broke because she would give in when clients would haggle over their cost. Her son, Arthur Cone, managed her bills and helped keep her business afloat for a while until he died in a car crash. In 1962, after an eye operation for glaucoma, she was trying to continue to work when she was hit with a $12,800 bill for back taxes. Facing bankruptcy, she got a call from the IRS that "an anonymous friend," rumored to be Jackie Kennedy, had taken care of the bill.

Lowe worked until she lost her eyesight, retiring at 72. She lived out her last years in Queens, New York, and died at age 82.

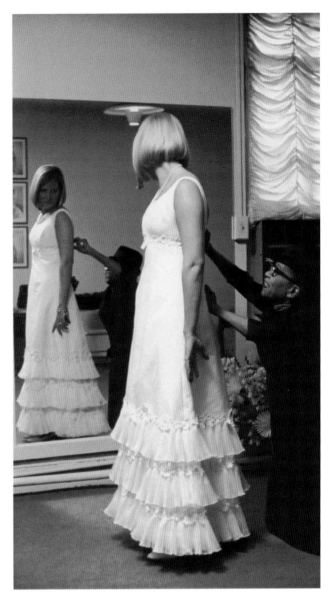

Lowe puts the final touches on a gown created for debutante Alberta Wangeman, 1966.

Emma Lazarus

1849–1887

The Poet of *The Statue of Liberty*

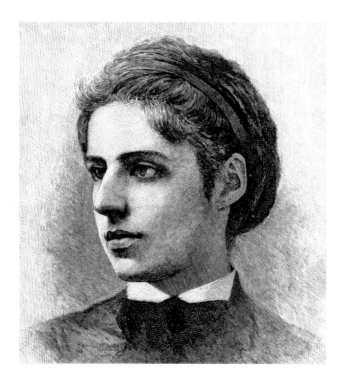

It's hard to see the Statue of Liberty and not think of Emma Lazarus' famous poem with the line "Give me your tired, your poor." Since 1886, the statue has been a symbol of hope and welcome in the harbor of New York City and the poem, an inspiration to millions of refugees, immigrants and visitors. But it wasn't always part of the famous monument and Lazarus never expected her poem to be part of history.

Many people don't know how the Statue of Liberty ended up in New York. Around 1875, Edouard de Laboulaye, a pro-abolitionist French historian proposed that France celebrate its long friendship with the United States by giving the country a public work of art. The gift would be a symbol of freedom, liberty and democracy, common values that united the two countries. It would also recognize the role that France played in helping the United States win its independence from Great Britain.

Frederic Auguste Bartholdi, a renowned French sculptor at the time, agreed to design and build the copper and steel statue. Donations from French citizens would cover the costs, while the United States would pay for the base to display the statute.

There was a lot of enthusiasm on both sides of the Atlantic for the idea, but raising the money was a harder sell. On the French side, the original goal was to have the statue completed, delivered, and installed by America's centennial in 1876, but that deadline was much too ambitious.

It would take a global crowdsourcing effort to raise the money. And the longer the campaign went on, the more expensive the project became. It wasn't until 1880, when millions of francs had been raised from thousands of citizens in 180 towns, villages and cities throughout France, that construction could begin.

Fundraising in the United States was also a struggle. After the initial enthusiasm, when it became clear that $250,000 would be needed for the base and pedestal, there were many voices of opposition. Leading newspapers editorialized against it, including *The New York Times* which called the project a "folly."

There was no money from the federal government either, because Congress couldn't agree on a spending package, and lawmakers fought over the kind of statute they wanted. New York Governor Grover Cleveland also prohibited New York City from allocating dollars for the project.

Just as in France, it would take a grassroots effort by ordinary citizens in America to ensure that Lady Liberty, the symbol of welcome, wouldn't herself be homeless.

In 1883, with the construction halfway done, The Bartholdi Pedestal Fund Art Loan Exhibition asked Emma Lazarus, Mark Twain and Walt Whitman, among others, to contribute original pieces of writing and art as items for

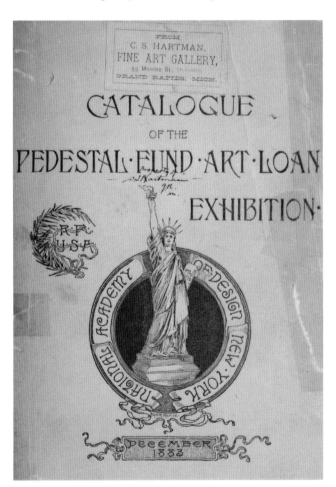

The poem, "The New Colossus," that Lazarus wrote to raise money for the Statue of Liberty, sold at the 1883 auction for $1,500.

auction. Lazarus, who had been writing and publishing since she was 18, at first said no. At 34, she had an impressive body of work—books of poetry, plays, a novel, essays that appeared regularly in newspapers and publications. "I couldn't possibly write verses to order," she was quoted as saying.

Lazarus was a literary star from a well-to-do family. Her privileged status would not have made her an obvious choice to write a passionate poem about freedom and immigration. She was born July 22, 1849, in New York City to Esther and Moses Lazarus, the fourth of seven children. A wealthy merchant, Moses had made his fortune in sugar refining. The Lazarus family was descended from Portuguese Sephardic Jews who had arrived in the city long before the American Revolution. By the 1850s, Moses was among the city's social elite. In 1871, along with the Vanderbilts and the Astors, he was a founder of the exclusive Knickerbocker Club.

The family lived in the Union Square neighborhood of New York City. Emma and her siblings were homeschooled by private tutors. Emma loved poetry and languages, and by 18 she had published her first collection of poems. Two years later, in 1868, Lazarus met poet Ralph Waldo Emerson, who was so impressed by her talent that he became her mentor.

Through her work at the *The American Hebrew* magazine, she learned about the pogroms in Russia and the persecution of Russian Jews who were fleeing their country, many landing in the lower East Side of New York City. As a volunteer for the Hebrew Emigrant Aid Society, she visited these new arrivals at the detention center on Ward's Island (today's Roosevelt Island). She was shocked by their squalid conditions and was reportedly on-site when the refugees began a riot in 1882. She started writing a newspaper column to let people know about their plight and began advocating for better conditions and organizing relief efforts. She also gave free English lessons to immigrants.

Although Lazarus was not an observant Jew, the antisemitism that forced the mass exodus of millions of Jews from Russia stirred her to activism and through her writing, she became a spokesperson for the Jewish American community. Long before there was a Zionist movement, Lazarus was advocating for a Jewish homeland in Palestine.

"Until this cloud passes," she wrote, "I have no thought, no passion, no desire, save for my people." She saw parallels

between how Jewish immigrants were mistreated and the discrimination against Jews she perceived among the upper-class circles her family traveled in.

Lazarus originally turned down the invitation to donate a poem to the auction for the Statue of Liberty, but the chairwoman of the auction convinced Lazarus that it was an opportunity to amplify her activism. "Think of the goddess of liberty standing on her pedestal yonder in the bay and holding the torch out to those refugees you are so fond of visiting at Ward's Island."

A few days later, Lazarus submitted a poem called "The New Colossus." Comparing the statue to the original, male Colossus of Rhodes, Lazarus named the statue the "Mother of exiles," who welcomed "the tired, the poor, the huddled masses yearning to breathe free. The wretched refuse of your teeming shore."

"The New Colossus" was read at the opening of the auction and sold for $1,500, worth about $45,000 in today's money. It was published in both *The World* and *The New York Times*, but then was forgotten. It was not read at the dedication of the Statue in 1886 or mentioned in press reports at the time.

Fifteen years later, Lazarus' friend and art patron, Georgina Schuyler, began a campaign to have the poem inscribed in the statue. Since 1903, a bronze plaque with the sonnet has been part of the pedestal of the monument, and an exact replica of it is in the nearby Statue of Liberty Museum.

Lazarus never lived long enough to see her work honored. She died in 1887 of Hodgkin's lymphoma in New York City at the age of 38.

THE NEW COLOSSUS

BY EMMA LAZARUS

Written for the PORTFOLIO *of the* ART LOAN COLLECTION *in aid of the* PEDESTAL FUND

Not like the brazen giant of Greek fame,
With conquering limbs astride from land to land,
Here at our sea-washed, sunset gates shall stand
A mighty woman, with a torch, whose flame
Is the imprisoned lightning, and her name
Mother of Exiles. From her beacon-hand
Glows world-wide welcome; her mild eyes command
The air-bridged harbor that twin-cities frame.

"Keep, ancient lands, your storied pomp!" cries she,
With silent lips. "Give me your tired, your poor,
"Your huddled masses, yearning to breathe free;
"The wretched refuse of your teeming shore —
"Send these, the homeless, tempest-tost to me —
"I lift my lamp beside the golden door!"

In 1903, the poem was inscribed on a bronze plaque at the base of the Statue.

The official title of the Statue of Liberty is "Liberty Enlightening the World." It was declared a national monument in 1924.

Elizabeth Hobbs Keckley

1818–1907

Dressmaker to First Lady Mary Todd Lincoln

"I have often been asked to write my life, as those who know me know that it has been an eventful one."

The spring of 1861 was a turning point in the life of Elizabeth Keckley, a 43-year-old African American formerly enslaved woman who had arrived in Washington, D.C. only a year earlier. In 12 months, she had started a dressmaking business aimed at serving the elite and famous women of the nation's capital, and it had taken off.

For the country, it was also a turning point. Jefferson Davis had just become President of the Confederacy, and Robert E. Lee would eventually become the General of the Confederate Army. As the country teetered on the brink of civil war, Varina Davis and Mary Randolph Lee became two of Keckley's most devoted clients while their husbands debated the fate of the Union.

That spring, Mrs. Lee's dress, created by Keckley for a glamorous party, was the talk of the city. Based on the positive buzz, Keckley's business boomed. She had to turn away clients, including a last-minute request by one of her best patrons, Margaret McClean, who refused to take no for an answer.

Mrs. McClean told Keckley that First Lady Mary Todd Lincoln was looking for a dressmaker. "I often heard you say that you would like to work for the ladies of the White House. Well, I have it in my power to obtain you this privilege. I know Mrs. Lincoln well, and you shall make a dress for her provided you finish mine in time to wear at dinner on Sunday."

Keckley knew this was an opportunity of a lifetime and she agreed, quickly hiring assistants to help complete the dress for Mrs. McClean's Sunday dinner.

And so on Tuesday, March 5, 1861, the day after Abraham Lincoln's inauguration, Keckley arrived at the White House. She found herself with three other dressmakers waiting to be interviewed by Mrs. Lincoln.

Unaware that Lincoln was interviewing other people, Keckley later wrote in her memoir, "I regarded my chances for success as extremely doubtful." But the new First Lady was very familiar with Keckley's reputation and talent. She was only concerned about the cost. "I cannot afford to be extravagant," Lincoln said. "We are just from the West and are poor. If you do not charge too much, I shall be able to give you all my work."

After agreeing on the fees, Lincoln first asked her to alter a rose-colored silk moire gown to wear to the inaugural parties. When Keckley returned with the alterations, the First Lady loved the changes so much, she immediately hired her.

Elizabeth Keckley walked into the White House as a seamstress and walked out a "modiste" (the French term for dressmaker and stylist) to the First Lady—a coup no one could have imagined given her race and status at such a tumultuous moment in history.

Her mother, Agnes Hobbs was a maid on a Virginia plantation who taught her daughter how to sew. As a young girl, one of Elizabeth's chores was mending clothes, but soon she began making clothes for family members of her enslavers. Elizabeth's father was the plantation owner although he was never officially acknowledged until her mother was on her deathbed.

Despite being a half-sibling to her father's white children, Elizabeth was treated as an enslaved worker, loaned or given away to work for other members of their extended family. She endured long hours of hard manual labor, physical beatings and abuse. As a young woman, she was raped and gave birth to a son, George Kirkland. But because she was so well liked, her enslaver father allowed her to learn to read and write, skills that were forbidden to the enslaved.

In 1847, the family she was working for fell on hard times. Keckley offered to take in sewing to help make ends meet. It wasn't long before her talents as a seamstress led to orders for dresses from the "best ladies in St. Louis." As an enslaved person, she was not allowed to keep any of the money, but the income was enough to support all 17 members of her enslaver's family.

While in St. Louis, Hobbs married James Keckley, who she had met in Virginia. Keckley told her he was a free man, but when she discovered he was a fugitive slave, the marriage began to disintegrate.

First Lady Mary Todd Lincoln wearing an Elizabeth Keckley gown.

Eight years later, Keckley wanted to buy her freedom. Her most devoted patrons loaned her $1,200 so she could pay for her and her son's freedom. Keckley went on to open a dressmaking business in St. Louis and begin paying off her debt. By 1860 she had repaid the loan. She divorced her husband, enrolled her son at college in Ohio and headed East in search of a better life.

In 1861, with Mrs. Lincoln her star customer, Keckley's shop on Twelfth Street expanded to 20 seamstresses. The first year Keckley worked for Mary Todd Lincoln, she created 15 new dresses for her, changing Lincoln's entire look.

A Keckley dress was known for its beautiful fit and drape, with simple lines and tastefully placed trim and ribbons. Her dresses were a sophisticated departure from the florals and bright colors that Lincoln had been wearing for years. Because labels were not sewed into clothes at the time and clothes were often taken apart and repurposed into new designs, there are few examples of Keckley's work today. Among the examples that still exist is a purple gown she created for Mrs. Lincoln to wear to her husband's second inaugural, which is on display at the Smithsonian

National Museum of American History. A black- and-white buffalo plaid dress with a cape is at the Chicago History Museum. There is also a Matthew Brady photo of Mary Todd Lincoln wearing a Keckley creation.

Helping Lincoln dress for special events and parties, Keckley spent a lot of time at the White House and gradually became a close friend and confidante of the First Lady. Two women, who could not have come from more different circumstances, bonded. They were the same age and both would lose sons fighting in the Civil War. After President Lincoln's assassination, Keckley spent six weeks in the White House, helping the First Lady while she was grieving.

Mary Todd Lincoln left Washington depressed and heavily in debt, despite her original comment to Keckley about needing to be frugal. Keckley helped the former First Lady stage an auction of her jewelry and clothing, but the sale was viewed by many in the public as an embarrassment to President Lincoln's legacy and failed to generate much income.

Keckley's memoir, *Behind the Scenes: Or, Thirty Years a Slave, and Four Years in the White House* was published in 1868 and is still in print. It included recollections of private conversations between President Lincoln and the First Lady, including copies of Mary Todd Lincoln's letters to Keckley. Intended to provide a sympathetic picture of Mrs. Lincoln, it had the opposite effect. Critics were scandalized that an African American woman would write a tell-all book about life in the White House. Mary Todd Lincoln called it a "betrayal" of their friendship and the two never spoke again. The backlash also affected Keckley's business when she lost some of her clients after the book's publication.

After her dressmaking days, Keckley became the head of the Department of Sewing and Domestic Arts at the historically Black Wilberforce College in Ohio. She lived her final years at the National Home for Destitute Colored Women and Children in Washington, D.C. where she died in 1907.

ELIZABETH KECKLEY.

BEHIND THE SCENES.

BY

ELIZABETH KECKLEY

FORMERLY A SLAVE, BUT MORE RECENTLY MODISTE, AND
FRIEND TO MRS. ABRAHAM LINCOLN

OR,

THIRTY YEARS A SLAVE, AND FOUR YEARS IN
THE WHITE HOUSE

NEW YORK:
G. W. Carleton & Co., Publishers.
DCCC LXVIII.

Published in 1868, "Behind the Scenes" was part memoir, history and a tell-all that scandalized the public for its frankness about the Lincolns.

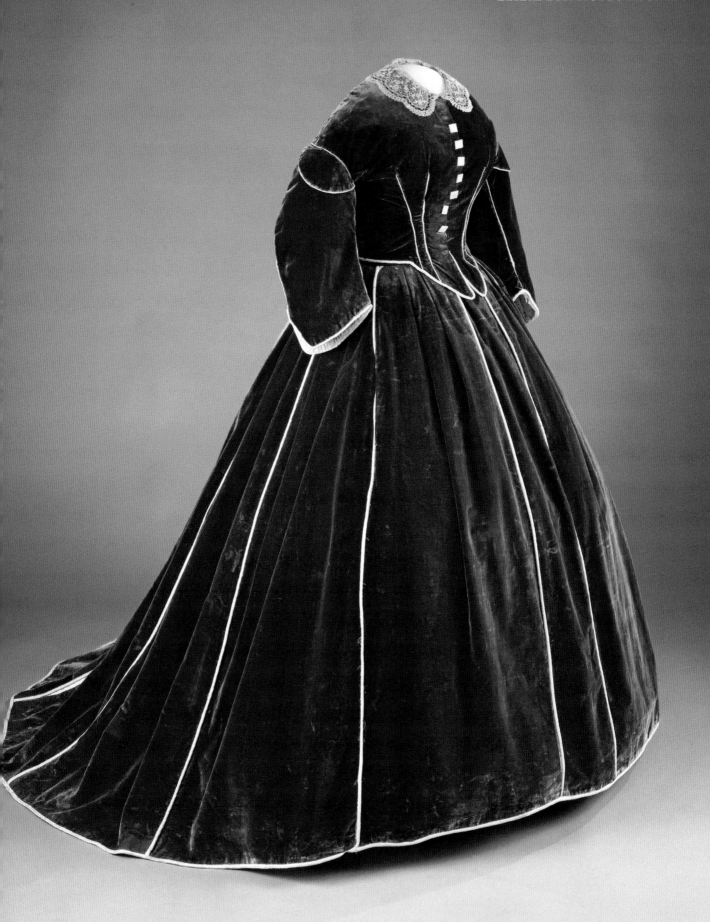

A purple velvet dress with white satin piping, believed to be a Keckley original worn by
Mary Todd Lincoln in 1861 is now in the Smithsonian National Museum of American History.

Ann Axtell Morris

1900–1945

Archaeologist, Author and Artist

"I want to dig for buried treasure, and explore among the Indians, and paint pictures, and wear a gun, and go to college."

Ann Axtell Morris, born February 9, 1900, was a pioneering female archaeologist who studied the indigenous people of the American Southwest and the Yucatan Peninsula in Mexico.

As a child, even though she didn't know the word for the profession she would later join, she expressed an early interest in things of the past. When asked at age six what wanted to do when she grew up, Axtell famously replied, "to dig for buried treasure, explore among the Indians, paint pictures, wear a gun, and go to college." Twenty years later, she became one of the first women archaeologists in a field well-known as a "boys' club."

It wasn't until Axtell was almost through college, however, that the light bulb went off. At Smith College, where she majored in history, she was dissatisfied that there weren't more classes on early civilizations and ancient cultures.

"Not until one of my harassed professors remarked wearily that what I probably wanted was archaeology and not history, did the light dawn," she wrote. After graduating from Smith in 1922, Axtell applied to the American School of Prehistoric Archaeology in France to pursue her dream of becoming an archaeologist. As she learned techniques for researching and excavating antiquities in the field, her goal became clear: to investigate and preserve one of the richest archaeological areas of the American Southwest known as Four Corners, where Arizona, Colorado, New Mexico, and Utah meet.

A year later in 1923, Axtell returned to the United States and married Earl Morris, the archaeologist believed to have inspired the swashbuckling film hero, Indiana Jones. Movie star handsome, and 12 years older, Morris was established and well regarded in his field. He had excavated a Mayan site

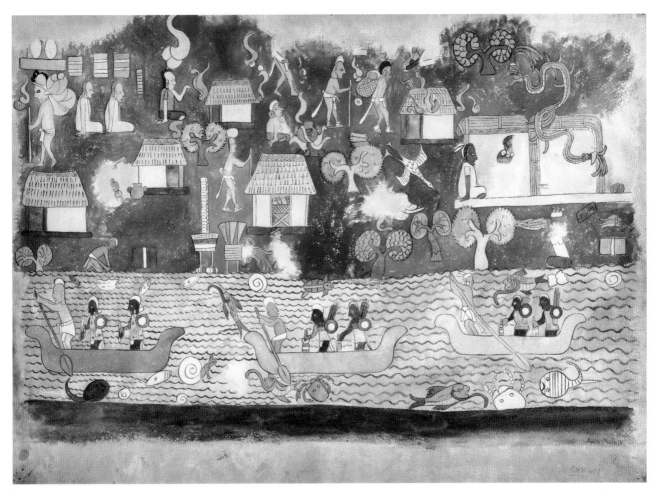

As her husband restored the murals found at the Mayan ruins of Chichen Itza, Mexico, Axtell Morris replicated them in color and astounding detail.

in Guatemala and restored the Aztec Ruins, a Pueblo site in New Mexico, for the American Museum of Natural History.

Despite the age difference, he was taken by Axtell's brains and beauty. In a 1921 letter to her family, Axtell said Morris would have hired her to oversee a dig, but his sponsors would never accept a woman.

"Needless to say," she wrote, "my teeth are much furrowed from much grinding." They were in love with each other and their work. They spent their honeymoon excavating remains in the unromantically named Mummy Cave, located in Canyon de Chelly National Monument in Arizona. They were the first to unearth mummified corpses and evidence of a thousand years of a highly advanced civilization, debunking the belief that the Anasazi were nomadic hunter-gatherers.

In the 1920s, American archaeological digs fired the public's imagination. But while there was huge interest in exploring the past, field work was mostly off limits to women. Determined to get in on the action no matter what it took, Axtell Morris dressed in gaiters, men's pants and boots and never flinched or complained about the rough camp conditions.

Despite her efforts, in 1924, when Axtell Morris arrived with her husband for an important dig in Chichen Itza, Yucatan, she wasn't handed a shovel and tools. Instead, Sylvanus Morley, the archaeologist in charge, expected her to babysit his children and serve as a hostess on the project. She ultimately convinced Morley to let her excavate an overlooked site, which led to astonishing discoveries about the Mayans.

Over the next five years, the couple returned to continue working on the site, which would lead to groundbreaking research about the Temple of Warriors, one of the most famous parts of the pre-Columbian city. As her husband restored the walls, Axtell Morris copied and reproduced the murals with astounding accuracy and detail.

She added color to her line drawings, something that had not been done before in archaeological renderings. The results of their efforts would become a two-volume book, *Temple of Warriors at Chichen Itza, Yucatan*, co-authored by the couple and French painter, Jean Charlot. Today many of Axtell Morris' reproductions are in a collection at the Peabody Museum at Harvard.

The couple also spent more than a decade documenting areas that are now part of America's national parks: Mesa Verde, the Aztec Ruins National Monument as well as Canyon de Chelly. At Massacre Cave in Canyon del Muerto in New Mexico, they were the first scientists to uncover the remains of Navajos who had been killed in a bloody attack by Spanish conquistadors. The Navajo elders had discouraged the couple from going there, calling it, *"The Canyon of the Dead Man,"* a cursed place.

One of the ways that Axtell Morris' brought indigenous cultures to life was creating large scale watercolors illustrating the ruins, pictographs, tools, people and landscapes of the region. In the traditional archaeological world, this was revolutionary. Her works of art were so captivating that she received commissions for specific sites. Her painting of the Canyon's iconic Antelope House, was displayed at a New York City museum. The National Park Service used her art to create new standards and methods for pictorial documentation.

Axtell Morris was instrumental in helping Earl Morris write his technical reports. She also compiled her own notes and drawings into two books, *Digging in the Yucatan*, and *Digging in the Southwest*. Because the publishers did not believe an archaeological book by a woman would sell, they were marketed as children's books.

While parts of her writing reflected the bias of her time toward indigenous cultures, the work that Axtell Morris and Morris did in the Southwest helped make the case for preservation versus looting of cultural sites. Many of these areas were eventually designated national parks or landmarks.

Her passion for her work led her to write that the three most important tools for an archaeologist were "a spade, the human eye and imagination," with "imagination being the most important of all and the most easily abused." Ironically, as she worked to bring the artifacts and dead cultures to life, her own contributions were often overlooked or buried in papers where her husband received the credit.

In 1932, the couple settled in Boulder, Colorado where the first of two daughters was born. But the transition to a traditional family life did not go well for Axtell Morris. While her husband continued to burnish his reputation and career with new projects in the field, Axtell Morris reportedly became a recluse, rarely emerging from her bedroom. Suffering from depression, diabetes, arthritis and alcoholism, she died in 1945 at age 45.

In her short life, Axtell Morris' displayed extraordinary courage and determination to follow her passion in the field of her dreams. She defied the sexist thinking of her time and shattered stereotypes. Her legacy has inspired and paved the way for generations of women archaeologists.

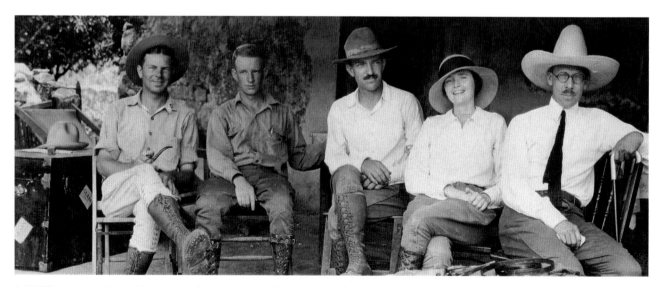

J. O. Kilmartin, engineer; Monroe Amsden, assistant archaeologist; Earl Morris, archaeologist; Ann Axtell Morris; S. G. Morley, head archeologist. Chichen Itza, Mexico. May 21st, 1924.

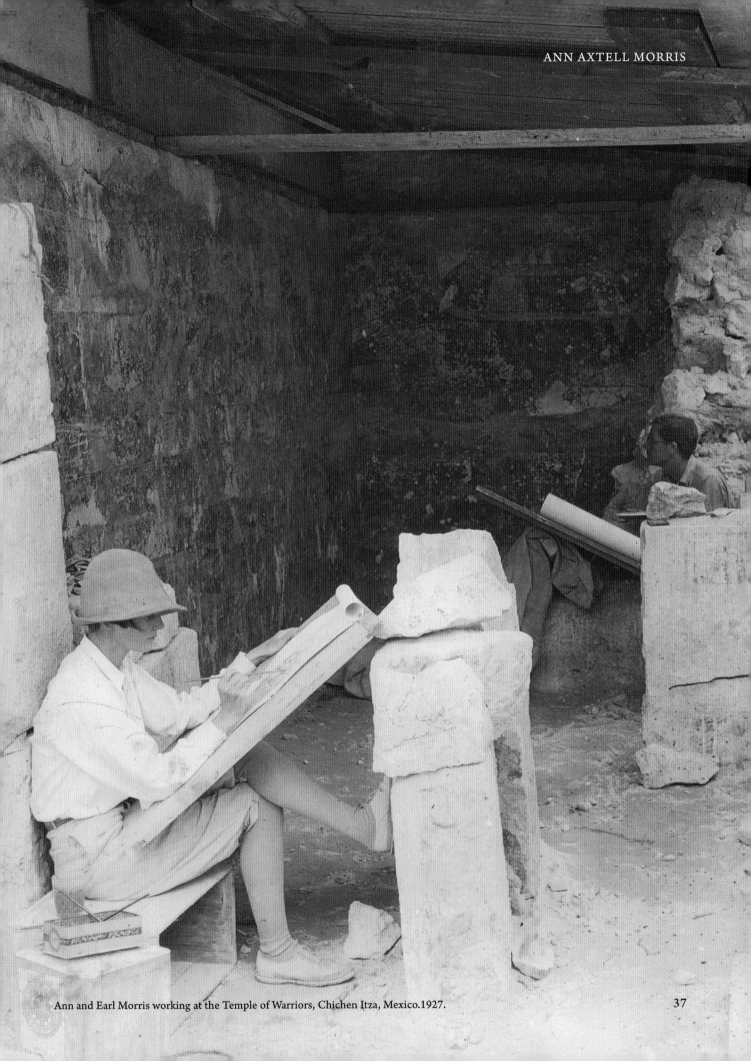

Ann and Earl Morris working at the Temple of Warriors, Chichen Itza, Mexico. 1927.

Louvenia "Kitty" Black Perkins

b. 1948

Creator of Black Barbie

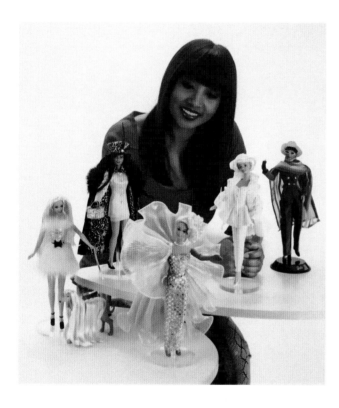

"She's black! She's beautiful! She's dynamite!"

As a little girl in an African American family of seven children, "Kitty" Black Perkins' parents couldn't afford to buy her a Barbie doll. Instead, she played with dolls that her mother, a housekeeper, received from her employers. It wasn't until she was an adult, applying for a job as a clothes designer at Mattel, that Perkins bought her first Barbie in preparation for an interview. That Barbie changed her life and in turn, Perkins changed Barbie for generations of girls of color.

Perkins was born and grew up in Spartanburg, South Carolina. Her family was far from wealthy, but her parents encouraged her creativity. In school, Perkins excelled at art. At home, she made her own clothes, starting with a jumpsuit, quite a complicated outfit for a beginning project. She was in love with color and fabric and learned to sew, cutting dress patterns out of old newspapers.

She was also a good student, and in 1966 Perkins graduated from Carver High School with a scholarship to Claflin College, a historically Black college in nearby Orangeburg. That summer after graduation she visited her aunt, Beulah Mae Mitchell, in Los Angeles, a big trip for a teenager who had never left her small town in the South. The trip opened her eyes to another world, and before the summer was over, she wanted to stay in California. If she could get into a college and get a job, her aunt told her, she would happily let Perkins live with her.

Even though it was too late to apply for the fall semester, Perkins put herself on the waitlist to attend commercial art classes at the Los Angeles Trade-Technical College. While she waited to hear about acceptance, she took a fashion design course, getting some formal skills to add to her home sewing knowledge. Once enrolled at the L.A.

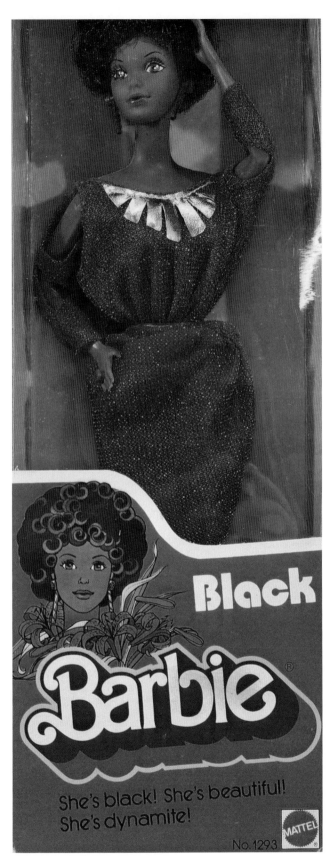

The first Black Barbie hit the shelves in 1980, at the height of the Black power movement that declared, "Black is beautiful."

Trade-Technical College, Perkins thrived, winning awards and getting noticed for her student fashion designs. After graduation, it didn't take long for her to find work as a children's clothing designer for JCPenney, Bloomingdale's, and Sears.

Then in 1976, she saw a blind ad for a fashion designer. She applied, not knowing who the employer might be and was surprised when the recruiter told her Mattel was looking for a clothing designer for the Barbie line. Her audition for the interview would be a new wardrobe for the iconic doll, which was turning 17 years old that year. Perkins had no problem making outfits for adults and children, but an 11½-inch doll was a challenge. Still, she went all out, sparing no expense to make a handsewn floral print jumpsuit made of voile with puffy sleeves, tiered pant legs and a matching wide-brimmed hat.

At first, the Mattel hiring director rejected her design, saying it was "too elaborate and too expensive" for mass production. But another director, sensing that Perkins' flair might just be what the Barbie line needed, gave Perkins a second chance, telling her to come back with cheaper but stylish looks. Perkins returned with six outfits, including a tunic with a bull's-eye pattern on the front, matching shorts and high boots and a white flared dress with black patent leather trim, a hat and sandals. The director took all the designs to a vice president and Perkins was hired on the spot. Later that year, to her amazement, all six designs were on the shelves. It was a dream debut for a rookie toy designer and the start of a 28-year career that reshaped the doll industry.

Years later, recalling her first week at Mattel, Perkins said she began her first assignment for the company, by simply "sitting and brushing Barbie's hair," trying to experience the doll from a child's perspective. It was her thinking process, she said. "After working on this doll for the first time," Perkins was hooked. "I can't do anything else," she remembers thinking. Three years later, in 1979, came the breakthrough assignment to create an outfit for the first Black Barbie.

For 20 years, through the social turmoil of the 1960s and '70s, Barbie had always been white and mostly blond. Responding to critics who wanted toys to better reflect the diversity in the population, Mattel produced three dolls to broaden Barbie's world. In 1967, they introduced Francie, Barbie's "mod" cousin from England. Although

her skin was darker, all of her features were identical to Barbie because she was made from the same Barbie mold. In 1968, Christie, Barbie's friend, arrived. Although she had a dark complexion and more identifiable African American features, her character was limited and she lived in Barbie's shadow until she was discontinued. In 1969, the Celebrity Barbie line added Julia, based on the character from the highly acclaimed television series of the time. The show, *Julia* starred Diahann Carroll as an African American widow with a son and a career as a nurse.

But none of these dolls had the appeal of Barbie. In creating Black Barbie, Perkins deliberately remade the doll's image to be more authentic. "My whole intent was to make Black Barbie look like us," Perkins said, explaining why she gave her a short Afro haircut with a pick. Influenced by black cultural icons she admired, including Diana Ross and the Supremes, Perkins dressed Black Barbie in a red bodysuit, disco skirt, dangly earrings and trendy necklace. She said, "When I design something, I imagine that it would be something that I would wear if I was in that particular situation. Because if it's not something that I would wear, then I don't think it would be something the children would like and something the Afro-American parents would embrace."

In 1980, when Black Barbie launched, Perkins wanted this new doll to reflect confidence, sophistication and a little glamour. At a time when the Black power movement was proclaiming "Black is beautiful," the slogan on the box for the doll clearly made the point: "She's black! She's beautiful! She's dynamite!"

For Perkins, the most gratifying part of creating Black Barbie was seeing and hearing the reactions of girls: "'Oh Mommy, look at the doll, she looks just like me.' Or 'She has pretty skin.' That reaction... was very rewarding to me."

Perkins would go on to have a legendary career at Mattel, becoming Barbie's designer of fashions and doll concepts. On average, she created more than 100 new designs a year for Barbie. In addition, she created the *Shani and Friends* doll collection as well as the MC Hammer doll. Multiple company and industry awards, including Doll of the Year, recognized Perkins' talent and groundbreaking creations.

Kitty Perkins broke barriers when she became the first African American toy designer at Mattel. Black Barbie became an icon to millions of girls of color. Its addition gave toy companies the freedom to create dolls of all ethnicities, body shapes, and in an array of real world situations.

Decades later, Barbie is still a popular doll that shows no signs of losing its powerhouse draw. In July 2023, the movie *Barbie*, starring Margot Robbie, and Ryan Gosling as Ken, opened in a blockbuster box office weekend. Four months earlier, in March 2023, the documentary *Black Barbie* premiered at the South by Southwest festival. The film explores the issues of representation and how one doll transformed the lives of generations of girls of color.

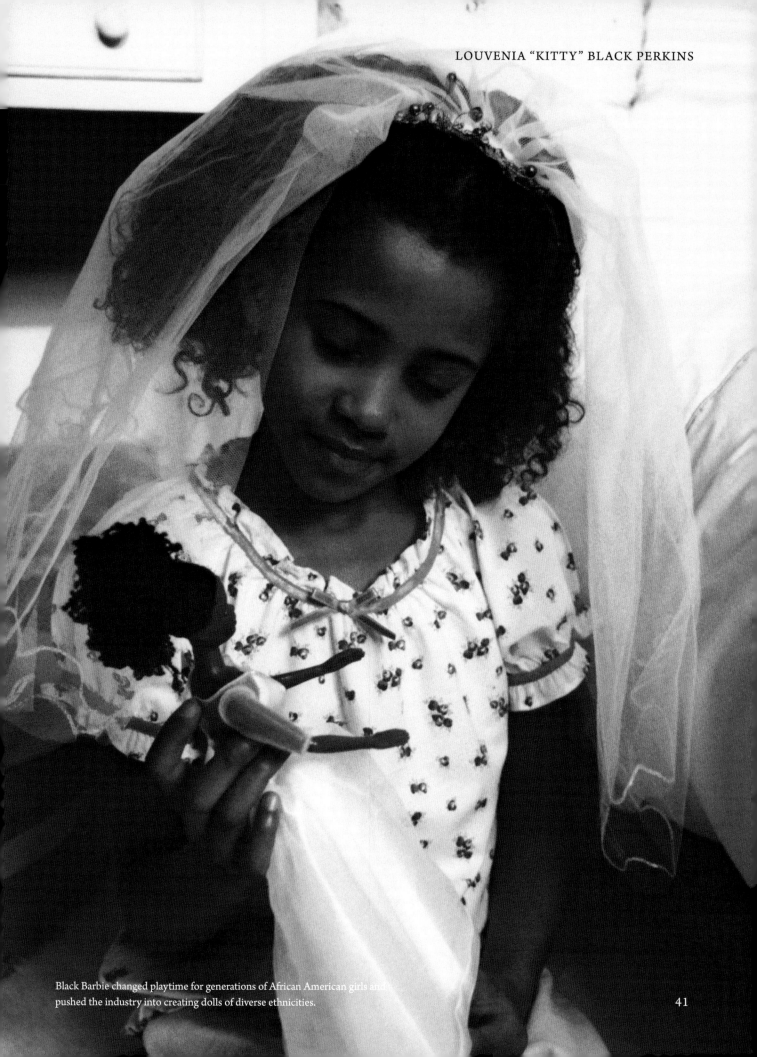

Black Barbie changed playtime for generations of African American girls and pushed the industry into creating dolls of diverse ethnicities.

41

*"I was always looking outside myself
for strength and confidence, but it comes
from within. It is there all the time."*

ANNA FREUD

The Firsts

Libby Riddles

b. 1956

Champion Dog Sled Racer

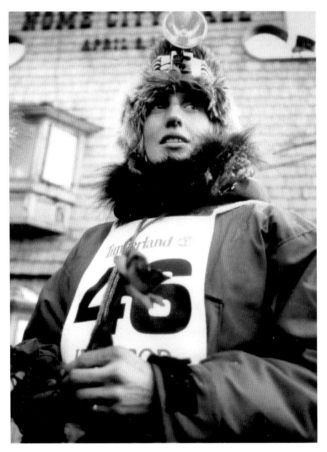

Libby Riddles in front of Nome City Hall, moments after crossing the finish line to capture the winner's title on March 20th, 1985.

"The moment when I won the Iditarod is going to be a pretty hard moment to beat, ever, in my whole life, really."

The Iditarod Trail Dog Sled Race is legendary for its treacherous route of frozen rivers, dense forests and tundra. Throw in sub-zero wind chills that can drop to minus 100 degrees Fahrenheit and the race justly earns its nickname as "The Last Great Race." The grueling thousand-mile competition tests the physical and mental endurance of the dual-species teams that make up the racers: the humans, called mushers and their canine partners.

In 1985, 28-year-old Libby Riddles became the first woman to win the Iditarod. Her victory was even more remarkable because she was a newbie to the world of dog sled racing and a virtual unknown to her competitors.

Riddles was born April 1, 1956, in Madison, Wisconsin. Describing herself as a mostly shy kid who preferred spending time with animals over people, Riddles grew up around dogs and dreamed of living on a ranch or farm. In 1972, after graduating from high school in St. Cloud, Minnesota, she and a boyfriend moved to Alaska to become homesteaders.

Dog sled racing and mushing were never in the picture. Solitude and adventure were what Riddles was seeking. She found it in a beautiful and remote place called Stony River, located in the foothills of the Alaska Range, home of Denali, the highest point in North America. With the closest airport 190 miles away and barely any car traffic, this was paradise to Riddles.

She learned to hunt and live off the land in a log cabin she built. As she picked up survival skills from Native American neighbors, she quickly realized that "sled dogs were the best kind of animals to have here" for getting around the vast territory that was her backyard. In 1975, she got her first sled dogs and began training them, "with

no intention of racing them." That all changed when Riddles began attending sled dog races and fell in love with the sport. In 1978, she entered a small competition as her first race. When she took first place, she was hooked.

In 1980 and '81, Riddles entered the Iditarod, finishing in 18th and 20th place, far from the top. But rather than being discouraged, she was energized by what she learned in those two races. And she decided to join forces with another veteran musher named Joe Garnie to breed and train dogs specifically to race in the Iditarod.

"Our styles of mushing were different, so we complemented each other," Riddles said. "I learned pretty quick that I didn't want to be a dog handler... I wanted to be on the sled."

In 1984, after taking third in the Iditarod, both Garnie and Riddles knew they had a dog team that could win the top spot. What they weren't sure of was whether Riddles had the chops to manage the team and bring home the gold.

The 1985 Iditarod was the 13th year of the race. Would it be the lucky one for Riddles and her 15 dogs? Barely one hour in, Riddles had doubts when her dogs took a wrong turn, overturning the sled and tossing her into the air. The team kept going even when she landed on her face, dragging her along until she could regain control of the sled. The rest of the race didn't get any easier. Once, as she dozed off while the dogs sped through the night, a limb struck her face, knocking out her headlight and leaving her bleeding from a gash on her nose. She once lost her dogs when they hijacked the sled during a rest break. Luckily, they were found by another racer and tied up waiting for her at a checkpoint on the route.

Riddles survived all of that only to face the biggest threat of all in the final days of the race. Over the last two weeks, officials had stopped the race twice because bad weather prevented airlifts from bringing food to checkpoints for the dog teams. Now a vicious arctic storm was forcing teams to hunker down in the tiny village of Shaktoolik, 130 miles from the finish line.

Except for Riddles, who pushed on, "telling myself how foolish I was being for doing this because the weather was just miserable. But I figured if it does pan out, it might help me win the race. So, I'm going to try it even if it's crazy." The gamble paid off. Even when she took a 12-hour break when the weather got too severe and then got lost on the final 22-mile stretch, she was able to take the lead and win.

Libby Riddles with some of the huskies she raises and trains in her Homer, Alaska kennel.

When her lead dogs, Axle and Dugan, crossed the finish line in Nome, Libby Riddles' winning time was 18 days, 20 minutes and 17 seconds, besting her closest rival by about 2½ hours. "They're a fine bunch of dogs," Riddles said, giving them the credit for the race. "I did my part to make sure and keep them up, keep them happy and healthy and in good shape. It looks like it really paid off."

Although she never won another Iditarod, Riddles continued to compete for two more decades, all over the world and in the lower 48 states. She moved to Homer, Alaska, and opened a kennel where she continues to raise and train sled dogs. She's written books about her dog sled racing career and is an icon in the sport. Her remarkable story has inspired other women to join this rarified breed.

Jeannette Rankin

1880–1973

First U.S. Congresswoman

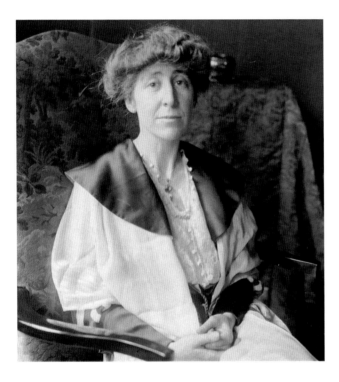

"I may be the first woman member of Congress, but I won't be the last."

Four years before American women won the right to vote, Jeannette Rankin made history by becoming the first female elected to Congress. When she was sworn into office as a Republican congresswoman on April 2, 1917, she was the sole woman among 434 men in the ultimate boys' club, the House of Representatives.

On her first day in office, she introduced a bill that would become the 19th Amendment, granting women legal voting rights, and later became the only woman to vote for the amendment. A pacifist who never wavered from her anti-war stance, she voted against committing the United States to World War I and II—two consequential votes that defined and doomed her short political career.

Jeannette Rankin was born on June 11, 1890, on a ranch in Big Sky country outside Missoula, Montana. Her parents, Olive and John Rankin, had seven children, and Jeannette was the oldest. Her father, originally from Canada, was a successful builder and businessman. Her mother was a schoolteacher. Rankin attended Montana State University, graduating in 1902 with a degree in biology. After college, unsure of what she wanted, she tried different jobs, including teaching and being a seamstress. She got a degree in social work from the New York School of Philanthropy and worked briefly as a social worker for an orphanage in Washington state.

Rankin became involved in the suffrage movement while in Washington, helping make that state the fifth one in 1910 to grant women the right to vote in statewide elections. Energized by the victory, she discovered her calling in the suffrage cause. For several years, as a field secretary for the National American Woman Suffrage Association, she traveled to 15 states, including her home state of Montana, to get out the vote for the women's vote.

All eyes were on Rankin when she gave her maiden speech in Congress in 1917. The galleries above were packed with suffragists witnessing the historic moment.

In 1916, two years after Montana became the 10th state to give women the vote, the state's two at-large congressional seats were up for election. Rankin decided to run for office. By now she was well known for her suffrage stance, and her campaign focused on that and other progressive issues, including child welfare and prohibition. Rankin captured enough votes to win one of the seats, launching her career in politics.

On the morning of Rankin's swearing-in, she rode in a 25-car motorcade to the Capitol where Montana's other congressman, John Evans, escorted Rankin onto the House floor.

Sustained applause and curiosity greeted her as she stepped into the chamber and when she took the oath of office. During the campaign, reporters had dissected her positions on domestic issues, but now, more of the attention was personal, as if she were an oddity in a male kingdom: the color of her hair, what she wore, her favorite recipes, the fact that she was single.

She received requests for speaking engagements, marriage proposals, product endorsements and photographs. Rankin endured the celebrity-like attention and declared, "I may be the first woman member of Congress, but I won't be the last."

Rankin's first day at work wasn't only ceremonial. She introduced her first bill: Resolution 3, the Susan B. Anthony Amendment, which stated: "The right of citizens of the United States to vote shall not be denied or abridged by the United States or by any State on account of sex." Eventually, this language would become the 19th Amendment when it was passed and signed into law three years later.

After presenting the bill, her day still wasn't over. That evening, she was back in the chamber at a special joint session of Congress, listening to President Woodrow Wilson ask for a declaration of war on Germany "to make the world safe for democracy."

A "yes" vote would take the United States into World War I. Three days later, as Congress began debating the war resolution, Rankin, a devout pacifist, was being pressured to vote in favor of going to war. Suffragists said a "no" vote from the first woman in Congress might set back the movement. Women would be seen as weak, with no stomach for politics or war. Most of the Congress and the country was leaning toward war, and others, including her brother who had managed her election campaign, argued that Rankin's opposition would be a throwaway vote that could end her political career.

"I want to stand by my country," Rankin said when her name was called, "but I cannot vote for war. I vote no." Forty-nine other congressmen also voted "no," yet it was Rankin's vote that made headlines. In newspapers across the country, her judgment was called into question. There were calls for her to resign. Montana's leading newspaper, the *Helena Independent*, likened her to "a dagger in the hands of the German propagandists, a dupe of the Kaiser, a member of the Hun army in the United States, and a crying schoolgirl." Some suffrage groups who had just pledged their support for her, canceled meetings and issued statements saying Rankin did not represent the movement on this issue.

Despite the backlash, nine months later, Rankin used the war vote to help make a case for the women's suffrage bill she had introduced. On the House floor during the debate, she pointedly asked her colleagues, "How shall we explain to them [women] the meaning of democracy if the same Congress that voted for war to make the world safe for democracy refuses to give this small measure of democracy to the women of our country?"

Later that month, with women cheering from the galleries, the House voted to pass the bill. It was the first time any women's suffrage measure had won approval in Congress. But the victory didn't last when the bill died in the Senate.

Rankin's anti-war vote was still fresh in voters' minds when her Congressional term came up for re-election two years later. Montana had redistricted the state and now Rankin was representing a mostly Democratic district. She opted not to run for re-election but instead declared her candidacy for Senate. When she lost that race, she knew it was time to quit traditional politics.

Over the next two decades, Rankin became an anti-war activist. She attended the International Women's Conference for Permanent Peace in Switzerland and became a member of the Women's International League for Peace and Freedom. In the 1930s, she was a lobbyist

Rankin was front and center in this partial portrait of the 65th Congress, a class comprised of 434 men and the first Congresswoman.

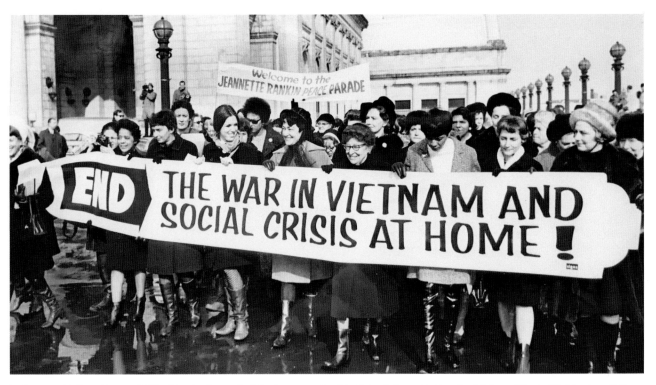

In January 1968, a 78-year old Rankin, in glasses, led the Jeannette Rankin Brigade in protesting the Vietnam War in Washington, D.C.

for the National Council for the Prevention of War, testifying before House and Senate committees.

By 1939, with the world on the brink of another war, Rankin decided the peace movement needed to have a seat at the table. In 1940, she returned home to Montana and ran for Congress again on an anti-war platform, winning 54 percent of the vote. It was 25 years after her first election, and there were now half a dozen other women serving in the House. Rankin said, "No one will pay any attention to me this time, there is nothing unusual about a woman being elected."

But they did pay attention the day after Pearl Harbor was attacked by the Japanese. On December 8, 1941, Congress was once more asked to vote on a declaration of war. Rankin was not allowed to speak during the debate and pressured to vote in favor or abstain. When the roll call was finished, the vote was 82-0 in the Senate and 388-1 in the House in favor of the resolution. Rankin was alone as she cast the only "no" vote to a chorus of boos and hisses. "As a woman," she said, "I can't go to war and I refuse to send anyone else."

As the press and House members swarmed around her, Rankin left the chamber and hid in a phone booth until police officers could escort her to her office. Rankin paid heavily for her vote. For the remainder of her term, many of her colleagues refused to work with her, the press ignored her, and she got backlash from her constituents as well. At the end of her term, in a repeat of history, Rankin again declined to run for re-election.

After two tumultuous terms in Congress, no one would have faulted Jeannette Rankin from retiring permanently from public life. But she never lost her passion for pacifism and never stopped believing in giving peace a chance. In 1968, during the Vietnam War, she led the 5,000-member Jeannette Rankin Brigade in a protest march in Washington, D.C.

By her 90th birthday in 1970, political sentiment had turned. The House, once the bittersweet scene of her historic victory, threw a party in her honor. In 1972, she was called "the world's outstanding living feminist," by the National Organization for Women.

Rankin died at 93 on May 18, 1973. At the time, she was reportedly considering another run for the House to protest the Vietnam War.

Bessie Coleman

1892–1926

First African American and Native American Female Aviator

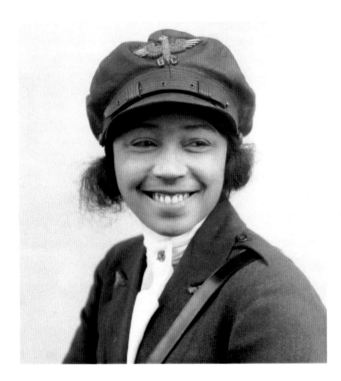

"The air is the only place free from prejudice."

Bessie Coleman dared to dream big when she fell in love with airplanes and flying. She chased her dreams of soaring higher and higher despite enormous discrimination as a woman of color in the early 20th century.

Elizabeth "Bessie" Coleman was born on January 26, 1892 in rural Atlanta, Texas, the 10th of 13 children. Her mother, Susan, was an African American maid and housekeeper. Her father, George, who was part-Native American, part-Black, was a farmer and a cotton picker. In the Jim Crow era, those were among the most common jobs available to anyone of color in the South. Segregation and discrimination spurred George to move to Oklahoma with some of the children in hopes of more opportunity. Coleman stayed with her mother in Texas, where she attended a one-room schoolhouse. At 18, she was accepted to Colored Agricultural and Normal University in Langston, Oklahoma. But after just one semester, she had to leave when money ran out for college.

By 1915, the Great Migration was in full force and Coleman joined millions of other Black Americans heading north. She arrived in Chicago, where two of her brothers had settled, enrolled in beauty school and became a manicurist in a South Side barbershop. There she got inspired and challenged to fly. According to accounts, her brother, John, recently back from fighting in Europe during World War I, told her how progressive France was. There were women flying planes over there, he said, something Black women wouldn't ever be able to do here in America.

When she heard this, something clicked inside Coleman that made her determined to prove him and society wrong. But it wouldn't be easy. No flight school or pilot in the country would take her as a student because she was a

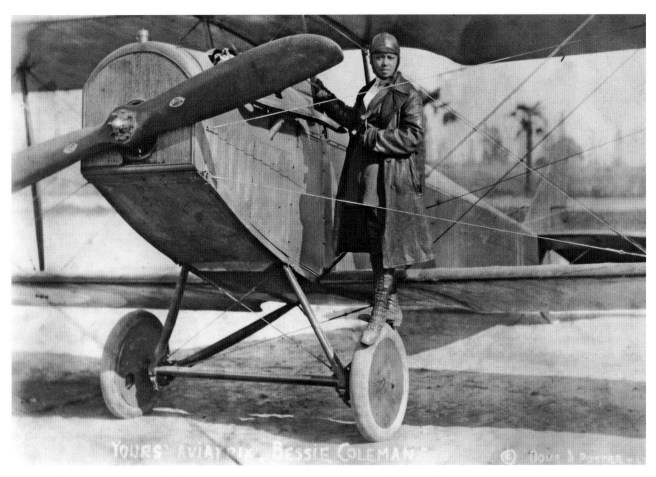

Bessie Coleman stands on the wheel of a Curtiss JN-4 plane wearing a custom pilot suit. 1924.

woman and African American.

Coleman had won a contest sponsored by a local Chicago newspaper as the best and fastest manicurist in the area. Through the contest, she met Robert Abbott, the newspaper's African American publisher who would become a friend and financial supporter. He urged her to consider going abroad to learn how to fly. Echoing Coleman's brother, he said the French were ahead of everyone else in training women pilots. Coleman took his advice and began taking French language lessons. On her small salary, she knew it would be years before she could scrape together enough money on her own to go to France for flying lessons. When Abbott wrote about her ambition to become a pilot in his newspaper, donations began to come in. Coleman applied to the renowned Caudron flying school in Le Crotoy, France, and in 1920, they accepted her into their training program.

In France, Coleman learned to fly in a 27-foot-long biplane, a flimsy shell of today's modern jets. It had a 40-foot wingspan, no brakes, no steering wheel and a wooden stick for maneuvering. The plane came down hard on landing, and the pilot had to deploy a metal skid on the tail to come to a full stop. There were no seat belts, and learning to fly it took courage, as Coleman found out when a fellow student died during one of her training sessions.

On June 21, 1921, having completed and passed the 10-month program in seven months, Coleman was granted a pilot's license from the Fédération Aéronautique Internationale. The license gave her the green light to fly anywhere in the world.

Few women were commercial aviators in the 1920s, and Coleman knew her best chance at a career was to become a barnstormer. Barnstorming, also known as a flying circus, was a hugely popular form of entertainment in the U.S. and Europe. To the audience, it was a dazzling display of skill and courage. For the pilots, it was daredevil dangerous. To do it, Coleman would need special training. In 1922, she took lessons from aviation specialists in

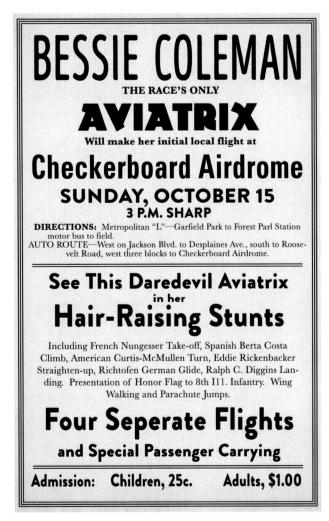

BESSIE COLEMAN

THE RACE'S ONLY

AVIATRIX

Will make her initial local flight at

Checkerboard Airdrome

SUNDAY, OCTOBER 15
3 P.M. SHARP

DIRECTIONS: Metropolitan "L"—Garfield Park to Forest Parl Station motor bus to field.
AUTO ROUTE—West on Jackson Blvd. to Desplaines Ave., south to Roosevelt Road, west three blocks to Checkerboard Airdrome.

See This Daredevil Aviatrix
in her
Hair-Raising Stunts

Including French Nungesser Take-off, Spanish Berta Costa Climb, American Curtis-McMullen Turn, Eddie Rickenbacker Straighten-up, Richtofen German Glide, Ralph C. Diggins Landing. Presentation of Honor Flag to 8th Ill. Infantry. Wing Walking and Parachute Jumps.

Four Seperate Flights
and Special Passenger Carrying

Admission: Children, 25c. Adults, $1.00

After returning from barnstorming lessons in Europe, one of Coleman's early performances was held at the Checkerboard Airdrome in Chicago in 1922.

France, the Netherlands and Germany before launching her exhibition career back home.

Coleman thrilled audiences with her stunts: loop de loops, figure eights in the air, sharp banks, parachuting and even walking on the wings of her plane while another pilot flew. Coleman had an uncanny sense of image. She performed often in a military-style costume and made herself up to be a strong, glamorous aviatrix. In no time, newspapers across the country crowned her Queen Bess and Brave Bessie for her performances.

Even as she became famous, Coleman still faced obstacles. Men resented her for doing what they wanted to do. Black women envied her beauty and poise but couldn't relate her career to their own struggles.

For a brief time, Coleman was courted by Hollywood.

She had a movie contract but broke it when the script called for her to play a dumb African American country girl. She said the role was demeaning and refused to do anything that compromised her dignity and values.

Coleman's dream of flying also had a larger purpose. She wanted to open a flight school and give Black Americans a chance to become pilots, literally giving them an opportunity to soar. She was saving her earnings to do that when in 1923 at an air show, the engine of her plane suddenly stopped working in mid-air. She crashed and broke a leg, cracked her ribs and suffered cuts and bruises. It wouldn't be the last accident she would suffer but while she recovered, she managed to fit in speaking engagements.

Touring the country, she showed films showcasing her exploits and promoted amateur aviation. She steadfastly refused to participate in any event that was segregated or discriminated against Black Americans. The money she received helped her buy her own plane and by 1925, she was back in the air performing. At an airshow in Texas, when the show operators insisted on separate entrances for Black and White customers, Coleman refused to perform. She and the managers ultimately compromised by agreeing to one entry gate but keeping separate seating sections.

In 1926 Coleman was in the passenger seat on a practice run for an air show when a loose wrench fell into the engine. The plane flipped over, nose-dived, spiraling into a tailspin and crashed. At the time, planes had no roof and no seatbelts. Coleman fell out of the plane, plunging to her death. She was 34. Her death was a shock to Americans who admired her bravery, fearless style and gutsiness. More than 10,000 people attended her funeral service in Chicago, which was led by African American journalist Ida B. Wells.

In her short career, Bessie Coleman boldly shattered stereotypes and more than exceeded her desire to "amount to something." She inspired generations of men and women of color to follow in the trail she blazed.

The Bessie Coleman Aero School, the flight school she so passionately wanted to create, was established in Los Angeles three years after her death. Other recognition took much longer. In 1995, the U.S. Postal Service issued a Bessie Coleman stamp. In 2005, 79 years after her death, she was enshrined in the National Aviation Hall of Fame. And in 2023, the United States Mint released a Bessie Coleman quarter.

Kirsten Neuschäfer

b. 1982

Champion Yacht Racer

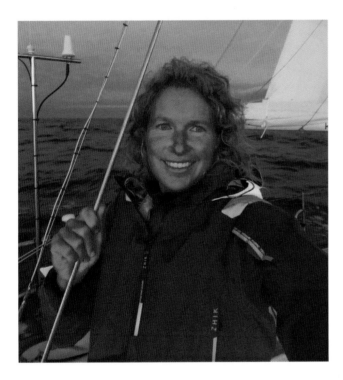

"It's not about having the latest technology: there is still a huge element of the unknown, a sense of adventure and a big element of luck."

On April 27, 2023, Kirsten Neuschäfer crossed the finish line of the Golden Globe Race after spending 233 days alone at sea, sailing a 36-foot-long boat around the world without any help.

No GPS, no radar, no satellite. Instead, she navigated by the sun, the moon and the stars. She used paper weather maps and nautical charts to determine where in the world she was. Like the mariners of the past, it was her seamanship that counted above all else.

Neuschäfer's win changed the race forever, making the Golden Globe Race "a voyage for madmen and one madwoman."

A curiosity about the world and a fearless appetite for adventure have always been in Neuschäfer's DNA. Born June 23, 1982, she grew up on the family farm outside of Pretoria, South Africa. She learned to sail dinghies as a child. And before becoming a professional sailor, she had plenty of adventures on land.

She spent years in northern Finland training Huskies and as a wilderness guide in Spitzbergen where she had to have a gun handy in case polar bears or other animals invaded her tent. At 22, traveling in Europe, Neuschäfer wanted to fulfill her dream of seeing Africa. Unable to afford an RV and undeterred by warnings and worries about a woman alone in Africa, she bought a bicycle in Germany, rode to Spain and ferried across the Strait of Gibraltar to Morocco.

Over the next 12 months, she covered more than 9,300 miles—exploring some of the most spectacular and remotest parts of the continent. She outwitted bandits and was detained by authorities who thought she was a spy. She also fell in love with the many villagers who were kind to a single woman on her own. When she contracted

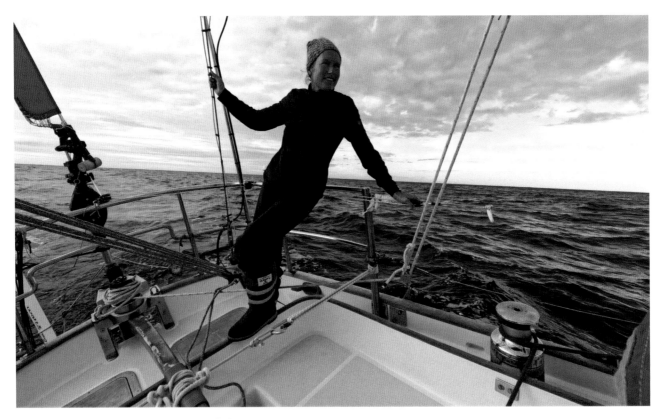

Kirsten Neuschäfer aboard her boat, Minnehaha. 2022.

malaria in the Central African Republic, villagers nursed her back to health, and by the time she was well, she had become her host family's "white daughter."

After becoming a professional sailor in 2006, she worked as a delivery skipper, sailing boats to clients in the Caribbean, New Zealand, and North and South America and Europe. Sailing all around the world, she learned the unique challenges of the oceans and waterways at different times of the year. She worked for a sailboat charter company, leading expeditions to the Arctic and Antarctic Oceans, Patagonia and the Falklands. She chartered crews for National Geographic and BBC for their shoots in Antarctica and South Georgia Island.

It wasn't until 2019, when Neuschäfer had just delivered a boat for repairs in Maine, that she learned about the Golden Globe Race. It offered the kind of adventure she craved, but she had no boat or money to buy one. Her friends helped her find sponsors and raise enough money once she had signed up for the race. The next two-and-half years would be spent preparing for one of the most unique experiences of her life.

In the sailing world, the Golden Globe Race is the retro race of the sport. It pays homage to the pre-high-tech days of the sport, specifically to a 1966 race by Sir Francis Chichester, who sailed solo around the world in his ketch, the *Gypsy Moth*. He made only one stop in a record 274 days. Two years later, inspired by Chichester's feat, a new race to sail solo around the world without modern technology was born.

This challenging new race called for a nonstop global journey around three major capes: Good Hope in South America, Cape Horn in Africa, and Cape Leeuwin in Australia. Only nine men entered that first competition in 1968. Of the nine, six quit before the end of the race, one committed suicide and the eighth man had to be rescued at sea when his boat sank. The winner, Sir Robin Knox-Johnston and his yacht *Suhaili*, finished in 312 days.

Knox-Johnston's record stood for 50 years until 2018, when organizers revived the Golden Globe Race. They wanted the race to recall the romance of a simpler time, a race that could serve as an alternative to modern races, where the biggest, most teched-out boats rule the waters. Instead, competitors had to sail on production boats, vessels that were mass produced. Boats designed

after 1988 and longer than 36 feet would not be allowed to compete. Only devices that were in existence in 1968, such as wind-up clocks, radios and cassette tapes would be allowed onboard.

For the 2022 race, Neuschäfer purchased a 1988 36-foot Cape George model yacht in Newfoundland that fit the race requirements. But the boat needed a massive overhaul. New floors for the deck, a new mast, cabinets to store books and 100 jars of food for the long months at sea. On Prince Edward Island, a talented local welder and machinist, Eddie Arsenault helped Neuschäfer refit her boat. The two of them did the majority of the renovation, spending all of 2021 on the restoration.

Neuschäfer wanted to know how every part of the boat worked so if she ran into trouble at sea, she would know how to fix the problem. In an interview, she said, "It's not about having the latest technology: there is still a huge element of the unknown, a sense of adventure and a big element of luck."

When the race began on September 4, 2022, 16 boats sailed out of the harbor of Les Sables d'Olonne, France to a 21-gun salute. Two weeks later, one yacht was shipwrecked in the Canary Islands. By early November, two more competitors had pulled out. One of them needed to be rescued from a life raft by Neuschäfer, whose boat was the closest to him.

While her rivals ran into problems with water, equip-ment and weather, Neuschäfer was making the most of the time. Having survived alone in remote places, she was perhaps better prepared mentally for the solitude that often drives sailors on solo voyages crazy.

"I really enjoy not having a GPS because it forces me to be observant," she said. "I enjoy not having detailed weather forecasts because it forces me to think more, and because it's a race and not a delivery, I like sailing the boat as fast as I possibly can." She also passed the time reading books, learning Xhosa, a language spoken in South Africa, swimming and writing in her journal.

Race organizers tracked the journeys of each sailor and their boat, but since the sailors are not allowed to contact one another, Neuschäfer had no idea how she or anyone else was doing. But the rest of world knew. As she rounded Cape Horn in February, with 8,000 miles left, she was in the lead. Then in March, she hit the doldrums, the zone around the equator where trade winds converge and often die, leaving ships at their mercy. When the winds changed, she sped straight for France, arriving to a victory welcome on April 27, 2023.

In winning first place in the Golden Globe Race, Neuschäfer also made history as the first South African sailor to circumnavigate the globe non-stop and unassisted.

"I wanted to win, not as a woman," she said. "I didn't want to be in a separate category but to compete on equal terms with all the skippers."

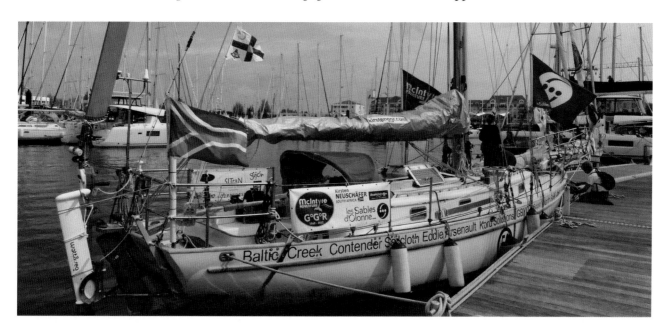

For 233 days, Neuschäfer's home was her boat, which carried her more than 30,000 miles around the globe.

"If I didn't believe the answer could be found, I wouldn't be working on it."

DR. FLORENCE SABIN

Scientists and Inventors

Katalin "Kati" Karikó

b. 1955

Biochemist, "Mother" of the Covid-19 vaccine
Winner of the 2023 Nobel Prize for Medicine

"Science is 99% challenge. You are doing things you have never done, or nobody has ever done. You don't even know if it is possible."

Decades before the COVID-19 pandemic, Katalin Karikó, born January 17, 1955, in Hungary, saw the potential of mRNA (messenger ribonucleic acid) for therapies and medicine. Her work on the science of mRNA laid the groundwork for the creation of life-saving COVID-19 vaccines, arguably the most significant medical invention of this century.

Her vision was acknowledged on October 2, 2023 when the Nobel Committee awarded Kariko and her collaborator, Dr. Drew Weissman, the Nobel Prize for Medicine. Their joint research resulted in "nucleoside base modifications that enabled the development of effective mRNA vaccines against COVID-19," the Committee wrote. "Through their groundbreaking findings, which have fundamentally changed our understanding of how mRNA interacts with our immune system, the laureates contributed to the unprecedented rate of vaccine development during one of the greatest threats to human health in modern times."

Contrary to skeptics in the anti-vaccine movement who say the COVID-19 vaccine was developed too rapidly, the real story is that it took years of persistent trial and error.

The woman who would one day be called a hero of the COVID-19 pandemic grew up in a two-room house in a small village two hours east of Budapest, Hungary. Karikó's father was a butcher and her mother a bookkeeper. A year after she was born, the failed Hungarian Revolution made life difficult under Communist rule. The family had no running water, no refrigerator, and a primitive stove. They grew their own vegetables and raised pigs. One of their neighbors had a cow. Nearby were forests and woods to explore. This was Karikó's childhood world, and it nurtured

Karikó in a lab at Uniformed Services University of the Health Sciences. Bethesda, Maryland, 1989.

in Philadelphia offered her a position in a postdoctoral program, Karikó happily accepted. She and her husband bought one-way tickets and sold the family car. Officially, it was illegal to leave the country with more than $100, but in the days before airports had X-ray screening, she smuggled the money from the sale of their car (about $1,200 in today's dollars) by sewing it inside her daughter's teddy bear. The bear survived the trip and years later, it sits in her daughter's old bedroom in Karikó's home, a reminder of how her journey to the United States began.

Over the next two decades, against huge odds, Karikó's devotion to her research never wavered, despite being dismissed and ridiculed at times by colleagues and rejected by grantors and the scientific community. At one point in her career, her husband calculated that with the extra hours she put in, her salary amounted to $1 an hour.

By 1989, Karikó was a researcher and assistant professor at the University of Pennsylvania's Medical School. It wasn't a prestigious teaching job on the tenure track, but rather a position that needed to be supported by grants, which were tough to win for mRNA. It had been nearly 30 years since mRNA first had been identified, however government and private companies were still not convinced about its potential for therapies and medicines.

There was also a lot of skepticism within the scientific community at Penn. Things changed in 1997 when Drew Weissman, an immunologist who had just finished a fellowship at the National Institutes of Health, joined the Penn Medical School. He wanted to develop a vaccine against HIV and was intrigued by the idea that mRNA could be the key to developing a new type of vaccine. Traditional vaccines like flu or measles inject a dead version of the virus into a person to spur the immune system to build up antibodies. A vaccine that did not contain a live or dead piece of the virus it was trying to fight would be not only revolutionary. It would also be potentially lifesaving, bypassing the years of trials required by traditional vaccines.

Unlike most collaborations, their introduction to each other did not happen formally or through their bosses or colleagues. Instead, they met while waiting to use the photocopier near their offices. In an interview for *Bostonia Magazine*, Weissman recalls, "I had always wanted to try mRNA," Weissman says, "and here was somebody at the Xerox machine telling me that's what she does." In the lab,

a lifelong love for science. It was a subject she excelled in as a student, and by eighth grade she was ranked number three in the country in biology.

From an early age, Karikó knew she wanted to be a scientist. But at the University of Szeged, Hungary, where she got her PhD and did postdoctoral work, she zeroed in on the new field of mRNA. She was fascinated by this tiny molecule that carried the genetic script to the body's cells to make protein, enzymes and other molecules that are the basis of human life. Karikó believed mRNA could be programmed to tell cells to make its own treatments to fight flu, cancer, stroke and other serious diseases. It was an exciting idea but one not easy to prove and also considered more than a little offbeat in the conservative scientific community.

In 1985, when funding ran out at the Hungarian university, Karikó had already spent several years working on mRNA. There was still so much more to investigate, and she refused to give up. When Temple University

On December 18, 2020 Dr. Drew Weissman and Katalin Karikó received the COVID-19 vaccine developed from their groundbreaking work on mRNA technology.

Weissman and Karikó's initial experiments failed when the mRNA they created triggered an inflammatory response in the cells. That inflammation would kill the already fragile mRNA, stopping their experiments cold. They spent several years trying to figure out why. The breakthrough came after they modified one of the chemical strands in the mRNA structure and encased the molecule in a fatty compound. By 2005 they were able to show that the mRNA vaccines they tested had been nearly 100 percent effective in protecting lab animals from getting infected and sick from more than 20 diseases, including flu, HIV, hepatitis and norovirus.

Karikó and Weissman filed patents and published their findings in scientific journals. But instead of a flood of congratulations, there was little reaction. Fifteen years before the outbreak of COVID-19, the world was not ready for their breakthrough research.

In 2013 Karikó retired from Penn and went to BioNTech, a pharmaceutical company, to work on developing a mRNA vaccine for cancer. When COVID-19 broke in January 2020, BioNTech was able to design a vaccine within hours. Researchers at Moderna, where another team was working on its own mRNA vaccines, created their vaccine in two days. By December 2020, after the first trials proved the vaccine's effectiveness, Karikó and Weissman were among the first to get vaccinated at the University of Pennsylvania.

Karikó's four-decade research not only saved millions of lives from a terrifying unknown virus, it also was proof of concept for a new way of developing vaccines for serious disease, as the Nobel Committee also recognized. "The impressive flexibility and speed with which mRNA vaccines can be developed pave the way for using the new platform also for vaccines against other infectious diseases. In the future, the technology may also be used to deliver therapeutic proteins and treat some cancer types."

Every remarkable story is not only about the facts of the struggle in a journey. It's also about the minor decisions and chance moments that later prove to be much more significant. For Kariko, these included the sale of a car, her daughter's teddy bear and a chance encounter over a photocopier. Those random events combined with a belief to follow her intellect and heart to wherever it might lead made all the difference for humanity.

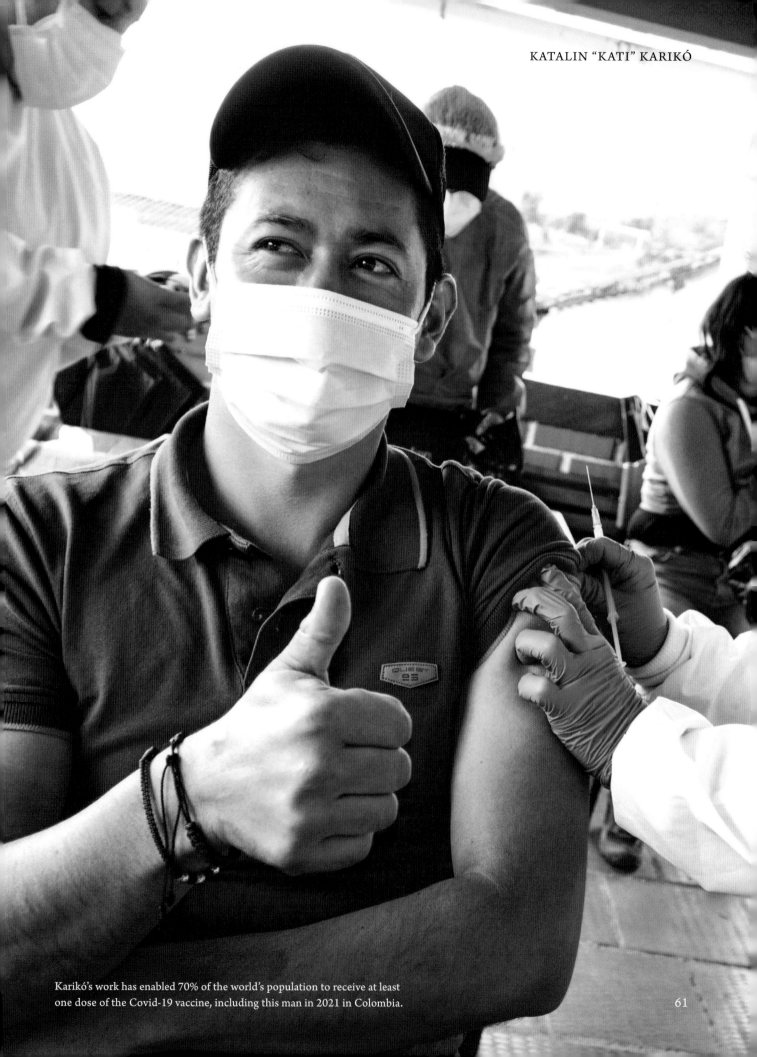

Karikó's work has enabled 70% of the world's population to receive at least
one dose of the Covid-19 vaccine, including this man in 2021 in Colombia.

61

Josephine Garis Cochrane

1839–1913

Inventor of the Dishwasher

"...they insisted on having their own way with my invention until they convinced themselves my way was better."

In 1870, Josephine Cochrane was leading the life of a prosperous wife of an up-and-coming lawmaker outside Springfield, Illinois. Entertaining was part of the job description of a politician's wife and Cochrane enjoyed being a hostess. The only thing she didn't enjoy was washing all the dishes, glasses and cutlery at the end of evening.

Why would a wealthy hostess be doing the dishes? Cochrane had servants, but when too many of her valuable porcelain plates were chipped and damaged after being washed, she rolled up her sleeves and took over the task. Her dishwashing days didn't last long and neither did her patience with finding someone who could create a machine that would do the washing for her.

So, in her typical "I'll do it myself" fashion, Cochrane set out to invent a machine that would eventually become the automated dishwasher we know today.

Cochrane was born into a family of inventors and engineers. Her grandfather, John Fitch, received the first patent for a steamboat and operated a steamboat route between Trenton, New Jersey, and Philadelphia, Pennsylvania. Her father, John Garis, was a civil engineer who had been involved in developing Chicago and later supervised mills along the Ohio River. No doubt her family's history of working with mechanical water equipment helped when she began inventing a better way to wash dishes.

Cochrane wasn't the first person to try to build a dishwasher. But it was her unique vision that made her version successful. Her design combined gears, pistons, pipes, racks and a motor that applied water pressure. The racks had compartments that firmly and safely held dishes tucked inside a wheel. As the motor turned the wheel, soap squirted onto the dishes. Pistons pumped water to wet and

rinse the load in two cycles. Water pressure was the secret sauce that made the design a success. Applying the right force of water left the dishes clean without damaging them. And a machine could clean more dishes faster than if they were washed by hand.

It was no surprise that when Cochrane shared her ideas with a few men for their feedback, she was met with skepticism. "They knew I knew nothing, academically about mechanics and they insisted on having their own way with my invention until they convinced themselves my way was better." Mechanic George Butters was one of the few men who did offer helpful advice, eventually creating the prototype that she would submit for a patent.

In 1883, Cochrane's husband died, leaving her with a large house and in debt. Suddenly Cochrane's idea might not only be a practical solution to a mundane housekeeping task, but also a potential source of income. By the end of 1886, after more tweaking and fine-tuning, she received a patent for the "Garis Cochrane Dish Washing Machine" and started Garis-Cochrane Manufacturing with George Butters as manager.

Cochrane initially targeted restaurants and hotels as customers for her dishwasher. In 1897, her first sales were to The Palmer House and The Sherman House, two famous, large Chicago hotels.

She supplied dishwashers to nine hotels for the 1893 World's Columbian Exposition in Chicago, also known as the Chicago World's Fair. The fair also became an excellent opportunity for Cochrane to market her invention. Held over six months, the fair showcased new ideas and inventions. It introduced visitors to the world's first Ferris wheel, moving walkway, Morse code telegraph and electrical lamps. Cochrane's dishwasher was displayed in Machinery Hall, the building featuring the latest technology where it was viewed by many of the 27 million visitors to the fair. To her delight, it won an award for "best mechanical construction, durability and adaptation to its line of work."

Her success at the Expo brought new clients. Hospitals and colleges were impressed by the sanitizing benefits of the hot water. As homes began installing boilers that could heat water up to the high temperature dishwashers required, Cochrane began making scaled-down dishwashers that could fit in a home kitchen, adding the consumer market to sales. It would be decades more before the dishwasher would become a common item in kitchens.

A remarkable businesswoman and inventor who defied stereotypes about women for her time, Cochrane covered miles of territory, traveling from Mexico to Alaska to sell her dishwasher until the year before she died. After her death in 1913, the company was sold twice, eventually becoming part of Kitchen-Aid, which today is now owned by Whirlpool. In 2006, she was posthumously inducted into the National Inventors Hall of Fame.

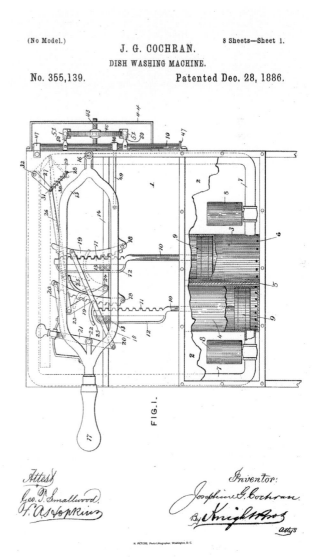

Cochrane's invention for her dishwasher was awarded a patent by the U.S. Patent and Trademark Office on December 28, 1886.

Marian Croak

b. 1955

Technologist and Inventor

"It's fine to be the only one—but you don't want to remain in that position... I make sure that the generation behind me can climb the ladder as well."

"I've always been motivated to change the world," Marian Croak says when she speaks about her career as an inventor, computer scientist and technologist.

"Change," would be an understatement when in fact, her research has revolutionized modern communication. Long before anyone else, she saw the potential of Voice over Internet Protocol, or VoIP, a technology that converts voice into a digital signal that can be transmitted over the internet on any device. VoIP is the foundation that led to Zoom, Skype, Cisco Webex and any number of similar apps that are now considered essential ways to communicate in today's world.

Croak's passion for innovation comes from a natural curiosity she had as a child and never lost.

She was born in New York City, May 14, 1955, into an African American family of modest means. Her childhood curiosity about how things worked went into overdrive whenever things around the house broke. When a plumber, carpenter or electrician arrived, Croak would look over his shoulder as he worked. She was fascinated by the inner workings of a sink, how many wires were inside a light fixture, or how the parts in a washing machine worked. At one point, she was so enthralled by fixing things that she thought she would grow up to be a plumber.

Croak attended Catholic school until 10th grade, when she transferred to a local public school. There, she found teachers who ignited her excitement in math and science.

"The teachers were just phenomenal," she recalled. "I remember having a chemistry teacher who was a woman and she just inspired me so much." Her father encouraged her passion for science by building her a chemistry set so she could conduct experiments at home.

After completing her undergraduate education at Princeton, Croak attended the University of Southern California. In 1982, with her doctorate in quantitative analysis and social psychology in hand, she was recruited to work at Bell Labs, a leading technology innovator of its time and the grandfather of today's AT&T.

The timing of the start of her career couldn't have been more perfect. She was working at Bell's Human Factors department at the dawn of the Internet age. One of her early assignments was to study digital messaging apps, programs that were way ahead of the time and required out-of-the-box thinking.

Often the only woman and person of color in the male-dominated labs and rooms at Bell, the soft-spoken and slight Croak could have been easily intimidated. But she wasn't.

In the early 1990s, when the company was looking to replace its legacy hardwire phone lines, Bell wanted to use a communications standard known as Asynchronous Transfer Mode or ATM. The alternative was next generation technology called Internet Protocol or IP, but it would require a bigger investment in new infrastructure and there would be a period of learning curves and risks that come with any new technology.

"I thought we were about to make a mistake by not moving to Internet Protocol," she said in a 2014 interview. "I realized I had to advocate—loudly!—for that technology if AT&T was going to maintain its leadership position. The key was to find a few coworkers who shared my conviction … our voices were able to win over others to our point of view."

Out of that conviction, VoIP was born. It has made remote conferencing standard business practice and relying on landlines for anywhere calling obsolete. While Croak spent a large part of her 32-year career at AT&T on VoIP development, it wasn't her only impact on our culture.

She even had a role in building the popularity of the television show American Idol. During the show's first season in 2002, viewers would vote for their favorite contestants by phone. A year later, even though texting wasn't yet a common means of communication, fans could text their vote thanks to an app Croak created. Afterwards a survey of fans revealed that almost a quarter of the people who responded said they learned how to text by using the "text to vote" app.

Three years later, in August 2005, the text app became a humanitarian tool when Hurricane Katrina wiped out homes and businesses in New Orleans. AT&T released a "text to donate" app that brought in $130,000. Five years later, when a magnitude seven earthquake decimated Haiti, that same app raised $32 million in relief funds. Donors simply texted the word "Haiti." The campaign set the pace for impulse donations and created a new fundraising format. The "text to donate" app was the brainchild of Croak and her co-creator Hossein Eslambolchi, for which they won the 2013 Thomas Edison Patent Award.

In 2014, after 32 years at AT&T, Croak embarked on a new chapter in her career by joining Google, where she has helped bring broadband to developing areas of Africa and Asia. As a vice president of engineering, she also leads the company's Research Center for Responsible AI and Human Centered Technology, where her blend of STEM skills and humanism will be more valuable than ever in developing products and solutions for the next generation technology. She also works on racial justice initiatives and encourages and mentors girls interested in engineering and science.

The holder of more than 200 patents, Croak was inducted into the National Inventors Hall of Fame in 2022 for her patent on VoIP. She became the second African American woman to be recognized with this honor.

The U.S. Patent and Trademark Office included Marian Croak in their Collectible Trading Card series, celebrating her as an inventor and problem solver.

Augusta Ada Lovelace

1815–1852

Math Genius

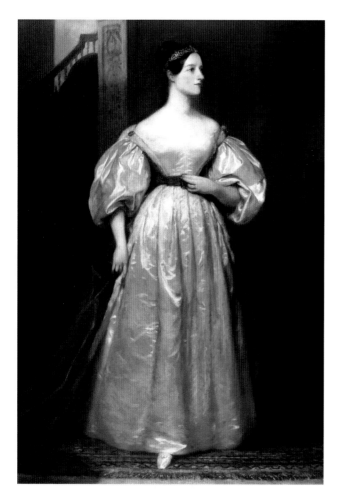

At a time when few girls were getting a basic education, Augusta Ada Byron, was creating the first known computer program in the world. That was in 1843, a full century before the first generation of modern computers were developed and 140 years before personal computers were produced. It was a time when the word "technology" as we define it today did not exist. The latest inventions were the telegraph, the fax machine and the typewriter. A math genius, Ada, as she was called, envisioned something called "the analytical machine," and it would become the basis for today's computers.

Augusta Ada Byron was born December 10, 1815, in London to parents who were completely opposite in temperament. Her father, George Gordon Byron, known as Lord Byron, was a renowned poet with a reputation as a charming philanderer. Her mother, Anne Isabella Milbanke, was religious, highly educated and a philanthropist who would establish the first industrial school in England. She also had such a talent for math that Byron called her "the princess of parallelograms." Their marriage lasted only 14 months, during which they were separated most of the time.

Ada never knew her father because her mother would not allow Byron to visit her. Believing that Byron was mentally unstable and would be a bad influence on their daughter, Ada's mother was determined to squash whatever imaginative or poetic interests she might have inherited from her father. Milbanke hired some of the era's most prominent scientists and mathematicians to tutor her daughter. Among them was the Scottish polymath Mary Somerville, who later introduced Ada to Charles Babbage, now regarded as the "father of computing."

As a child, Ada showed an early interest in math. At the same time, her imagination was far from being suppressed. At 12, after studying birds, she wanted to construct a flying machine. It's not clear whether she knew about Leonardo da Vinci's blueprint for a helicopter before she developed her own theory about flight in a paper called "Flyology."

She wrote, "I have got a scheme, to make a thing in the form of a horse with a steam engine in the inside so contrived as to move an immense pair of wings, fixed on the outside of a horse, in such a manner as to carry it up into the air while a person sits on its back."

In 1833, when Ada was 17, she met mathematician Charles Babbage, who gave her a demonstration of his Difference Machine, an early prototype of an adding machine or calculator. Ada's interest in the machine's potential led to a correspondence between the two, which developed into a long professional relationship.

Ada's marriage in 1835 to William King-Noel, who later became the 1st Earl of Lovelace, and the births of their three children did not end her interests in math and science. The more she studied and investigated, the more she believed that intuition and imagination were just as important as logical reasoning.

Several years later, she demonstrated how well she could integrate science and imagination. In the early 1840s, at a conference of scientists in Italy, Babbage presented his blueprint for an Analytical Machine, an invention capable of performing more mathematical functions and with greater accuracy than his Difference Machine.

Babbage's ideas prompted Luigi Menabrea, a mathematician in the audience, to write a report, later published in French. Asked to translate the report, Ada did more than that. In a lengthy series of notes, she laid out Menabrea's observations of how this machine could be programmed with a code to solve complex formulas.

Ada took Menabrea's theory further. She compared the Analytical Machine to a textile loom, a common mechanical machine of her time, that used punch cards to create designs out of threads. She posited that the Analytical Machine could also use punch cards to create algebraic patterns to make calculations.

As an example, she provided a step-by-step computation leading to a mathematical solution. Based on this example, Ada is credited by many as the first computer

programmer. Some math historians dispute this, saying Babbage had already formulated algorithms in his writings. Regardless of how Ada is regarded by modern day scientists, she was the first to explain the importance of the concept and its potential applications in a clear and compelling way to the world.

Ada's "Notes" to Babbage were forgotten until 1955, when they were included in a groundbreaking book called *Faster Than Thought: A Symposium on Digital Computing Machines*, by B.V. Bowden. The book was the first to give Lovelace credit for envisioning a field that didn't yet exist. Her theory was confirmed when the early computers of the 20th century were designed to store data by punching holes on cards to represent numbers or letters.

In Ada's brilliant vision of the Analytical Machine, she imagined that it "might act upon other things besides numbers… for instance… the engine might compose elaborate and scientific pieces of music of any degree of complexity or extent." For one of their experiments testing this theory, she and Babbage used the Analytical Machine as a betting device to predict horse races and events. Ada was able to see possibilities more than a century before the phrase "there's an app for that" would become commonplace.

Whether Ada was the first programmer or not, her legacy as a pioneer in computer science is secure. In 1979, the U.S. Department of Defense developed a computer language that would codify all the different languages in use by the military. They named it ADA in her honor, and it's still in use today in the banking, aviation, health care and space industries.

In her lifetime, Ada's contributions were uncelebrated, partly because her ideas were so far ahead of her time. The telephone didn't exist, radio waves hadn't been discovered and photography was still a new fascination. Women weren't allowed to study at universities. Ada Lovelace's genius was overlooked, but her legacy survives in nearly every aspect of our world today.

"I had been sent to Europe to do my job, which was not to report the rear areas or the woman's angle."

MARTHA GELLHORN

Women and War

Cornelia Fort

1919–1943

Aviator

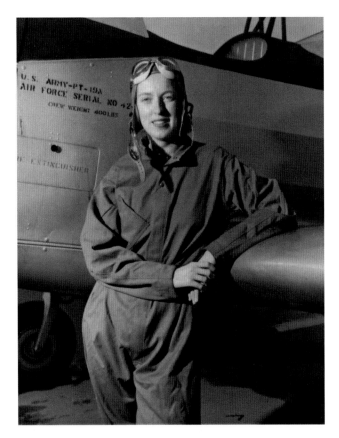

"I... am profoundly grateful that my one talent... flying, happens to be of use to my country when it is needed."

There was nothing about Cornelia Fort's comfortable childhood and privileged upbringing in Nashville Tennessee that would have provided any clues about her legacy as an aviation pioneer. Her father, Rufus Fort, was a successful businessman and one of the founders of the National Life and Accident Insurance Company in Tennessee. Fort's mother, Louise Clark Fort, was a homemaker and socialite. Tradition, genteel values and an aversion to making waves were the vibe of the Fort household.

Fort lived in a 24-room mansion on a 365-acre estate called Fortland. A chauffeur drove her and her siblings to private school. When she turned 19, her father presented her to society at a debutante ball in Nashville. Flying airplanes was never in the picture. In fact, her father disapproved of airplanes so much that he made his sons promise they would not take flying lessons. They promised, but little did Rufus Fort know that it was Cornelia he needed to be concerned about when it came to aviation.

As a teenager, Fort was already developing into an independent young lady. In 1936, her parents enrolled her at the Ogontz School for Young Ladies in Pennsylvania, coincidentally, the same boarding school that Amelia Earhart attended years earlier. Like Earhart, Fort was not happy there and complained about the school's "gray and oppressive" atmosphere.

She wanted out and convinced her father to let her transfer to Sarah Lawrence College in Bronxville, New York. The contrast between the two schools could not have been more different. Sarah Lawrence was a better fit for Fort's spirit and interests. She studied literature and writing, joined multiple clubs and became an editor of the campus newspaper.

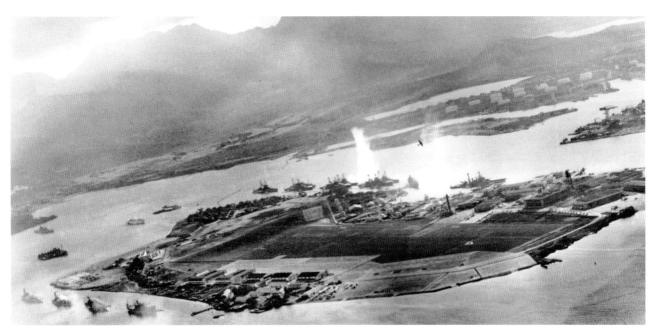

A Japanese torpedo hits the battleship U.S.S. Oklahoma early in the attack on Pearl Harbor, Dec. 7, 1941.

After graduation in 1939, Fort returned home to Nashville and fell back into the city's high society scene. In January 1940, a friend who happened to be a flight instructor, offered to take her for a ride in his single-engine plane. That ride changed her life forever. She fell in love with flying instantly and wanted to take lessons right away. From all accounts, she was a natural in the cockpit and within a month she was flying solo.

In March 1940, shortly after her first lesson, her father, who was not aware of her flying lessons, fell ill and died. After his death, Fort's passion for flying quickly became the focus of her life. By the end of the year, she had enough hours to acquire both her private and commercial pilot licenses. And by Spring 1941, she earned an instructor's rating, becoming the first female flight instructor in the state.

Fully qualified as an instructor, she was hired to teach at the Civilian Pilot Training Program in Fort Collins, Colorado. She was the only female instructor there. On her first day of work, the administrators were in shock; they thought they had hired a man. The program, run through colleges and universities, was aimed at training future pilots with an eye toward military preparedness for America's potential involvement in the war in Europe.

In the fall of 1941, Fort moved closer to the action when the Andrew Flying Service offered her a job teaching defense workers, soldiers, and sailors to fly in Honolulu,

Hawaii. It was a job she loved, calling it "the best job I can have (unless the national emergency creates a still better one)." She described the planes as "big and fast and better suited for advanced flying."

On the morning of Sunday, December 7, 1941, Fort was in the instructor's seat in a small Interstate Cadet plane, with her student, Ernest Suomala, flying above Pearl Harbor. It was early and there were few other planes in the beautiful skies above the island. They were wrapping up their lesson when a fast-moving plane suddenly appeared in their flight path. "It was in violation of air traffic rules," she recalled later. "I waited for it to give way… and when it didn't, I jerked the stick out of the student's hand and pulled the plane up."

Fort's quick last-minute action avoided a collision. But in the shock over the close call, they didn't realize the plane was a Japanese Zero until they looked out the window and saw the red sun on the side of the fighter jet as it passed under them. In seconds, Pearl Harbor was engulfed in black smoke as bombs rained down from waves of Japanese planes. Fort managed to land her plane in a spray of gunfire and she and Ernest ran for cover.

As terrifying as the experience was, Fort calmly reported the incident in her logbook: "Flight interrupted by Japanese attack on Pearl Harbor. An enemy airplane shot at my airplane and missed and proceeded to strafe John Rodgers,

Fort's plane log on December 7, 1944: "Flight interrupted by Japanese attack on Pearl Harbor. An enemy plane shot at my plane and missed and proceeded to strafe John Rodgers, a civilian airport. Another plane machine gunned the ground in front of me as I taxied back to the hangar."

a civilian airport. Another airplane machine gunned the ground in front of me as I taxied back to the hangar." Fort didn't know it at the time, but she was the sole woman aviator in the skies during the attack and was possibly the only eyewitness in the air of the attack as it was unfolding.

The attack on Pearl Harbor pushed the United States into World War II and changed the trajectory of Fort's flying career. While she became a celebrity when she returned home to Nashville due to her close call in the sky, she wanted to do more than give interviews about her experience and promote the sale of war bonds.

Over the next few months, as the need for male pilots grew more intense, a fight raged within the military about using women pilots to take over non combat duties. First Lady Eleanor Roosevelt promoted the idea, but many generals opposed it, arguing that women weren't strong enough to fly military planes or didn't have the required experience.

But by late 1942, with men heading into battle overseas, the Women's Auxiliary Ferrying Squadron was formed with the Army's blessing. The WAFS would later merge with the Women's Flying Training Detachment to become the Women Airforce Service Pilots (WASPS), a unit that would play an important role in the war. More than one thousand women accepted into the program underwent 27 weeks of specialized training that taught them to fly all types of military planes.

Before they were disbanded, WASPs would ferry 12,000 military planes from factories to airbases over 60,000 miles. They would flight-test planes and serve as flight instructors. They freed up more than 1,100 men to fight in the war. Their skill and bravery proved their male doubters wrong.

Fort was the second woman to join the WAFS and was assigned to work out of Long Beach, California. Because the new planes had never been tested in the air before, Fort often was flying bare-bones open-cockpit planes. There was no radio communication and she had to navigate using landmarks for guidance. It was dangerous, but Fort loved it and was proud to be contributing to the war effort.

In March 1943, as she was guiding six planes from Long Beach to Love Field in Texas, one of the other planes piloted by a male officer with less than 300 hours flying experience, collided into Fort's plane sending her to her death.

At 24, Cornelia Fort became the first woman pilot in American history to die on active duty. She was buried at the Mt. Olivet Cemetery near her family home in Nashville. Of her accomplishments, she is quoted as saying, "I am grateful … that my one talent, flying … was useful to my country."

Thirty-seven other WASPs would die before the war ended but none received military recognition because they were considered civilians. After decades of lobbying, the WASPs were retroactively granted military status as veterans in 1977. But the fight still wasn't over. Another quarter of a century would pass before they would be granted the right to be buried in Arlington Cemetery.

Virginia Hall

1906–1982

The "Most Wanted" Spy of World War II

The Nazis called her the *"most dangerous spy: we must find and destroy her!"*

Virginia Hall always had an independent streak as a child. She was adventurous, liked to hunt and ride horses bareback. In high school, she was class president and editor in chief. Her classmates said she was the "most original" among them, but never would they have voted her "most likely to be a spy."

Hall was born April 6, 1906, into a wealthy Baltimore, Maryland, family. Her parents, Barbara and Edwin Hall, envisioned a life for her like theirs: comfortable, traditional and stable. She made the socialite scene and was engaged by 19 but broke off the relationship with her fiancé when she discovered he was unfaithful.

Bored at college, after one year at Radcliffe and another at Barnard, she convinced her parents to send her to Europe to finish her education. In Paris and Vienna, she studied politics, French, journalism and economics. By the time she graduated in 1929, she was fluent in five languages and immersed in European culture and politics. She considered France her "second country," and was troubled by the growing popularity of Adolf Hitler and fascism.

In the fall of 1929, after returning home from Europe, the stock market crashed, wiping out her family's fortune. Hall had already been accepted to graduate school at George Washington University. As she pursued her goal of becoming a professional diplomat, she decided to take the entrance exam at the State Department. When she was turned down, she was not aware that of the 1,500 officers in the service, only six were women. The Foreign Service was not a friendly place for women at the time.

In January 1931, Hall's father died of a heart attack. For the first time in her family's life, money was scarce. Hall applied again to the State Department and was hired for a

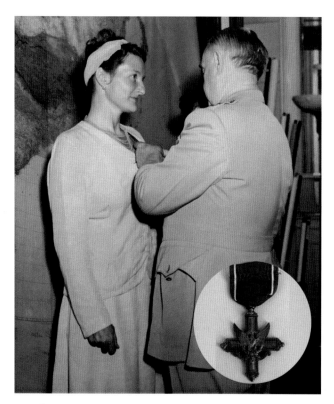

President Harry Truman wanted to present the Distinguished Service Cross to Hall in a public ceremony, but Hall insisted on a private ceremony to protect her identity. Her comment after the ceremony: "not bad for a girl from Baltimore."

clerical job at the American Embassy in Warsaw, Poland. She worked there for nearly two years before moving on to a similar post in Smyrna, Turkey.

On a hunting trip there, as Hall was climbing over a fence, her gun misfired. She had inadvertently shot herself in her left foot, leaving a wound that became infected with gangrene. By the time she got the proper medical attention, the infection was serious. Her leg had to be amputated below the knee and she was fitted with a wooden prosthesis.

It was a setback to her career ambitions she hadn't anticipated. But as she rehabilitated at her family home in Maryland over the next year, Hall became more determined than ever to prove herself despite her disability.

By November 1934, she was back at work, assigned to the American consulate in Venice. For the next three years, she threw herself into her job, mostly dealing with visas, passports and customs but also standing in when needed, for her boss, the vice consul.

By 1937, at age 30, with five years of stellar overseas experience, she was ready to revisit her dream of becoming

an ambassador. But once again, Hall was denied. Decades before the Americans for Disability Act, an obscure rule within the agency barred amputees from serving in the diplomatic corps. Hall refused to take no for an answer and appealed the ruling, which went as far as the Oval Office. Ironically, President Franklin Roosevelt, also disabled as a polio survivor, declined to intervene in her case.

Soon after, Hall was reassigned to Tallinn, Estonia, an outpost that was far from the center of the action in Europe. She felt the job was probably retaliation for her appeal of the agency's rejection. In March 1939, Hall quit her job, sensing that her career at the State Department was at a dead end.

It was a perilous time to be in adrift in Europe. Hitler's invasion of Poland in September 1939 triggered Britain and France to declare war on Germany, throwing the continent into turmoil. But instead of returning to the safety of America, Hall went back to Paris, where she volunteered with a French artillery unit. She was trained to drive an ambulance and rescue the wounded from the battlefields in the north. Hall worked as long as she could, but when Paris fell to the Nazis in June 1940, she fled south to Spain and then to London.

For once, Hall's timing was right. The British had just created the Special Operations Executive, a sabotage, guerilla warfare and spying unit. Hall had two strikes against her: her gender and her nationality as an American. She convinced the British to overlook both before she was accepted into their rigorous training program. Surprisingly, her disability was not an issue. By September 1941, as Agent 3844, code name "Germaine," Hall was in France.

Over the next four years, until the war's end, Hall led a double life. Posing as a special reporter for the *New York Post*, she was stationed in Lyon, a city that was the center of the French resistance. Working undercover, she became a master of disguise with multiple identities and names.

She befriended hundreds of ordinary citizens, recruiting them to become spies. Among them was the owner of a brothel whose prostitutes gathered information about the Nazis' plans from their clients. She organized teams of Resistance fighters, providing them with safe homes and training them to sabotage key German supply routes. Hall also coordinated supply drops of food, arms and equipment and masterminded daring operations to free resistance fighters.

It was dangerous work, and for the first time, being

female and disabled was an advantage. Believing that women and anyone who wasn't able-bodied couldn't be spies, the Germans never considered Hall a suspect. Eventually, they realized "the limping lady" was more than she seemed on the surface, and they offered a huge reward for information about her. Hunting her down became the obsession of Klaus Barbie, the head of the Gestapo in Lyon, who plastered the city with posters calling her "the enemy's most dangerous spy: we must find and destroy her!"

After nearly 15 months, in the winter of 1942, with the Gestapo hunting for her, Hall, with her wooden leg, hiked three painful days over the Pyrenees to escape to Spain. She survived, returning as a hero to Britain in time for Christmas.

Hall was far from quitting the spy life, but it was too dangerous to send her back to France. Instead, in May 1943, the SOE deployed her to Madrid, Spain. Officially she was a reporter for the *Chicago Tribune*, but her undercover assignment to oversee safe houses was too tame for her liking.

By now Hall's reputation as an intrepid secret agent was well known within the intelligence communities of the Allies, including the U.S. State Department and the Office of Strategic Services (OSS), the American secret service. Now, overlooking past objections about her gender, disability and inexperience, they had no qualms about sending her back across German lines.

In March 1944, disguised as an old woman, "Diane" was back in France. On D-Day that year, as American soldiers were landing in Normandy, Hall and her Resistance teams were inland, fighting and laying booby traps for German troops on the ground.

By August, after weeks of brutal battle, the German southern command, composed of 600 soldiers, surrendered to Hall and the Resistance in Le Chambon, liberating the region without any Allied military help. It was the beginning of the tide turning in the Allies' favor, and later, much of Hall's intelligence-gathering and operations were credited with laying the groundwork.

Le Chambon would turn out to be Hall's last mission, the capstone to a wartime spy career that began as a gamble, where the odds of a one-legged rookie surviving a mission were 50-50 at best.

Virginia Hall's remarkable heroism saved lives and contributed mightily to the Allies' success. She was the only civilian woman to receive the Distinguished Service Cross, the army's second highest award. Britain made her an honorary member of the Order of the British Empire, and France gave her the Croix de Guerre. For years the CIA kept her story classified and untold. Today the agency has a field agent training facility named for her, and Virginia Hall's story is part of the CIA Museum in Langley, Virginia.

12 May 1945

MEMORANDUM FOR THE PRESIDENT:

Miss Virginia Hall, an American civillian working for this agency in the European Theater of Operations, has been awarded the Distinguished Service Cross for extraordinary heroism in connection with military operations against the enemy.

We understand that Miss Hall is the first civilian woman in this war to recieve the Distinguished Service Cross.

Despite the fact that she was well known to the Gestapo, Miss Hall voluntarily returned to France in March 1944 to assist in sabotage operations against the Germans.

Hall was the only civilian woman to receive the Distinguished Service Cross in World War II and since then.

Martha Gellhorn

1908–1998

War Correspondent

"Why should I be a footnote to somebody's else's life?"

On D-Day, June 4, 1944, more than 156,000 American, British and Canadian soldiers stormed the beaches of Normandy, France, in an epic invasion that was the turning point in winning World War II.

Little known is that among those brave hordes was a woman—reportedly the only woman—who not only witnessed history but helped make it. That woman was Martha Gellhorn, who at 36, was a seasoned war reporter.

In 1937, Gellhorn was in Barcelona and Madrid, covering the Spanish Civil War, her first war assignment. She was a rookie, but her only fear, she wrote from Spain, was "that I would forget the exact sound, smell, words, gestures which were special to this moment and this place." From the start of her career, Gellhorn was committed to bearing witness to what was happening to humanity using the most honest, gutsiest language she knew.

Martha Gellhorn was born November 8, 1908, in St. Louis, Missouri. Her parents, George and Edna, were solidly upper-middle class. George was a successful gynecologist. Edna was a suffragist and advocate of progressive causes, who would later become one of the founders of the National League of Women Voters. As a young girl, Gellhorn remembers going to suffragist meetings with her mother, most memorably a rally at the 1916 Democratic National Convention in St. Louis.

Gellhorn attended Bryn Mawr, one of the elite Seven Sister colleges, where her mother had also studied. She quit after one year to try journalism. She wrote briefly for *The New Republic* magazine and a local Albany, New York, newspaper. Neither offered her the excitement of being a foreign correspondent. So, in 1930 she sailed to Paris to work briefly for the wire service United Press International.

A year later, Gellhorn was back in the United States as the country struggled through the Depression. She got a job working as a field investigator for the Federal Emergency Relief Administration (FERA) in New England and the Carolinas. Her job was to interview, observe and write about the impact of the Great Depression on the poorest people.

In essence, it was a reporting job that gave Gellhorn the opportunity to sharpen her journalistic skills: how to interview, how to track down information, how to apply statistics to real life situations and how to translate all of what she saw into compelling stories about real people. Her reports were so good that they were sent directly to President Franklin D. Roosevelt. Gellhorn would later team up with photographer Dorothea Lange, who shot pictures of the hungry and homeless for the agency. Together their words and images became part of the official government history of the Depression.

A few years later, after leaving the job, Gellhorn published a collection of fictional short stories called "The Trouble I've Seen." It was based on the people she had met and written about during her FERA experience. The book got good reviews and made Gellhorn a literary star.

That same year, 1936, on a family vacation in Key West, Florida, Gellhorn met one of her idols, best-selling author and journalist Ernest Hemingway. Both were writers and thrill junkies addicted to the kind of rush that only covering wars and crises can bring.

Their relationship quickly got complicated. In addition to his reputation as one of the new voices of American literature, Hemingway was a known womanizer. Married to his second wife at the time he met Gellhorn, they began an affair that would take them both to Spain to cover that country's civil war. From there, Gellhorn went to Germany, Czechoslovakia and Finland, reporting on Hitler's rise to

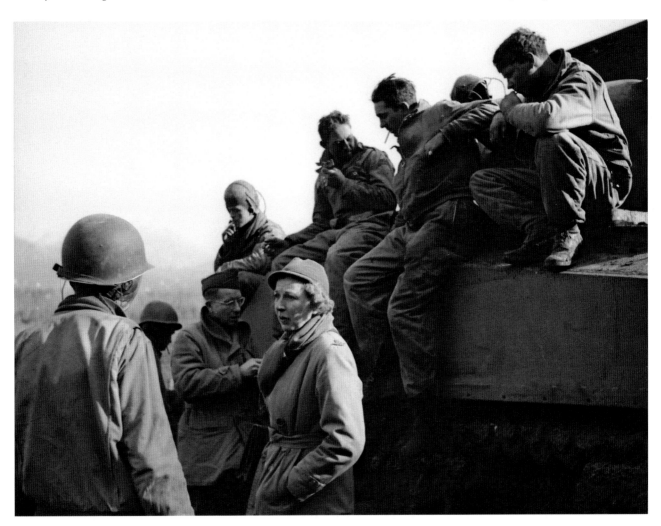

Gellhorn with Allied soldiers during the Battle of Cassino in 1944.

power and takeover of Europe. It was dangerous work and few journalists were doing it.

By 1940, a newly divorced Hemingway married Gellhorn. But unlike his first two wives, Gellhorn had no intention of quitting her successful career to become a full-time wife. "Why should I be a footnote to somebody's else's life?" she asked. Over the course of their short marriage, her career and work would be a constant source of conflict.

The longer World War II dragged on, the more in demand Gellhorn became as she built a reputation as one of the best war reporters around. In London after the Blitz in 1943, she was on her way to Italy to cover the war there when she received a letter from Hemingway. With one question, he summed up his jealousy and resentment: "Are you a war correspondent or a wife in my bed?" The answer from Gellhorn was simple. "I followed the war wherever I could reach it. I had been sent to Europe to do my job, which was

not to report the rear areas or the woman's angle."

For most of the war, Hemingway had stayed at their home in Cuba, content to read dispatches his wife had written from all over Europe. But D-Day was an epic event he couldn't miss. With their marriage on the rocks and knowing that women would not be allowed on the beach when the troops landed, Hemingway, by now a famous author, contacted *Collier's* magazine, where many of Gellhorn's articles had been appearing. He offered to cover D-Day for them. When they said yes, Gellhorn was shut out of the biggest story of her career, and in her mind the marriage was over.

Even though D-Day was officially off limits to women journalists, Gellhorn was determined to find a way to cover the war. She spent two weeks searching for a passage across the Atlantic and got a spot on a Norwegian freighter carrying dynamite and personnel carriers. On the docks

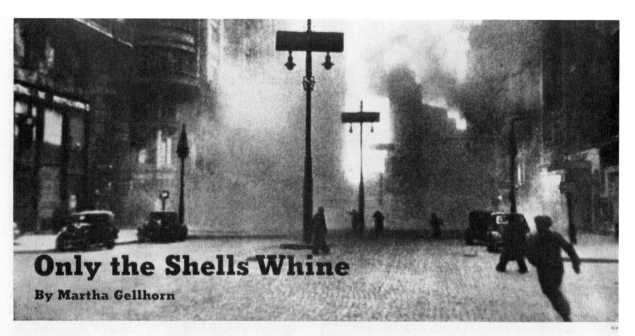

Only the Shells Whine

By Martha Gellhorn

AT FIRST the shells went over: you could hear the thud as they left the Fascists' guns, a sort of groaning cough, then you heard them fluttering toward you. As they came closer the sound went faster and straighter and sharper and then, very fast, you heard the great booming noise when they hit.

But now, for I don't know how long—because time didn't mean much, they had been hitting on the street in front of the hotel, and on the corner, and to the left in the side street. When the shells hit that close, it was a different sound. The shells whistled toward you—it was as if they whirled at you—faster than you could imagine speed, and, spinning that way, they whined: the whine rose higher and quicker and was a close scream—and then they hit and it was like granite thunder. There wasn't anything to do, or anywhere to go: you could only wait. But waiting alone in a room that got dustier and dustier as the powdered cobblestones of the street floated into it was pretty bad.

Street Scene, A. D. 1937, Madrid. When the shells begin to burst in your street the thing to do is go somewhere else as quickly as possible

This is Madrid, a large city, a modern city. People are living here and doing business. Elevators run; children go to school (hurry at the next corner; it's a bad crossing). And men drink beer, pausing occasionally to listen (you can tell how close a shell is by its whine). You spend your days and nights in waiting—waiting for the shelling to begin or waiting for it to stop. Miss Gellhorn shows you what life is like when death stalks the streets—and frequently comes indoors

In 1937, Gellhorn covered the civil war in Spain for *Collier's* magazine, her first assignment in her long career as a war correspondent.

Allied soldiers landing on Omaha Beach in Normandy, France on June 6, 1944.

in southern Britain, where the Allied ships were preparing to sail for France, she had to use all the ingenuity she had developed as a reporter to get even closer. Passing herself off as a nurse, she stowed away on a hospital ship. As the vessel crossed the English Channel, she locked herself in a bathroom.

At dawn, she awoke to an overwhelming scene: hundreds of destroyers, battleships and amphibious vessels offloading thousands of troops as bullets and gunfire erupted everywhere. All day, a steady stream of the wounded was brought onto the ship, and in the chaos no one questioned whether Gellhorn was a nurse or why a woman was so close to the action. Her D-Day stories, which ran in *Collier's*, were vivid reports of the wounded and of the heroism of the medics and doctors.

Two days later, on June 8, a small team from the ship, with Gellhorn as a stretcher bearer, made it onto Omaha Beach to retrieve more of the wounded. She wrote: "Everyone was violently busy on that crowded, dangerous shore. The pebbles were the size of apples and feet deep, and we stumbled up a road that a huge road shovel was scooping out. We walked with the utmost care between the narrowly placed white tape lines that marked the mine-cleared path and headed for a tent marked with a red cross."

After D-Day, Gellhorn stayed in Europe and was one of the few reporters to witness the liberation of the concentration camp at Dachau in April 1945. "Behind the barbed wire and the electric fence," she wrote, "the skeletons sat in the sun and searched themselves for lice. They have no age and no faces; they all look alike and like nothing you will ever see if you are lucky."

The war was over by September 1945, but Gellhorn's career as a roving war correspondent would last another 44 years. Over her six-decade career, she was on the ground for at least twelve major conflicts, including the Vietnam War in the 1960s, the 1967 Six-Day War in the Middle East, and Nicaragua in the 1980s. She reported from more than 50 countries. The final war she covered, at age 81, was the U.S. invasion of Panama in 1989. When war broke out in Bosnia in 1992, she was 84. "Too old," she wrote." You have to be nimble to cover war."

Throughout her career, Gellhorn believed in telling the stories of ordinary people, "the sufferers of history." She was not a believer in objectivity when it came to war and she had no fear of calling out lies or taking on the bad guys in her work.

In her last years, Gellhorn's health failed. Eye problems left her nearly blind and she had terminal ovarian cancer. In 1998, living alone in London, she committed suicide. She was 89.

Vesta Stoudt

1891–1966

Invented a Use for Duct Tape in World War II

"Dear friend, I hope you will take time to listen to a Navy mother's problem."

In February 1943, Vesta Stoudt was among the six million American women working in factories producing military equipment for the Allies fighting in World War II. A mother of eight children, including two boys who were serving in the military, the 52-year-old Stoudt packed and inspected cartridges used to launch rifle grenades at the Green River Ordnance Plant near her home in Sterling, Illinois.

Her job was to pack 11 cartridges in a box and seal the flaps with paper tape before the box was dipped in wax to make it waterproof. One end of the tape hung loose as a pull tab for ripping open the box. As she worked, Stoudt realized how thin the tape was and how often it tore off without opening the box of ammunition. The weak tape could be a risk for troops in combat, she thought, when every second counted to load and reload weapons.

Her son Clarence, 20, was on active duty in the Atlantic. Lowell, 26, was a construction mechanic serving in the Pacific. Knowing that their lives could be jeopardized due to a packaging flaw only added to her worries.

Stoudt thought, why not use waterproof tape reinforced with a thin cotton cloth instead of the flimsy paper tape? She reportedly experimented with different fabrics and tapes at home before bringing the idea to her bosses. They told her the solution was "all right," but that's as far as it went.

Frustrated but determined, Stoudt decided to go over their heads. Way over. On February 10, 1943, she wrote the most important letter of her life to "Mr. President."

"Dear friend," she opened, "I hope you will take time to listen to a Navy mother's problem." Describing her job at the Green River plant and the flimsy tape on the boxes, Stoudt added a small sketch to illustrate the problem.

Mr. President
 Dear friend, I hope you will take time to listen to a Navy Mother's problem. I am working at the Green River Ordnance Plant at Amboy, Ill. I am inspecting and packing cartridges. These cartridges are used to shoot the rifle grenades; which you know are being used on land and sea by our armed forces. We pack these in small boxes, eleven to the box. They are then taped and waxed to make them damp proof. They look like these when packed. ⬚ᵗᵃᵇ They are taped with a thin paper tape, and the tab left loose so

Dear Mrs. Stoudt,

I know you will be pleased to hear that we have received word from the Ordnance Department regarding your suggestions for changing the type of tape used on munition packaging.

The Ordnance Department has not only pressed the matter, but has now informed us that the change you have recommended has been approved with the comment that the idea is of exceptional merit.

We thank you for bringing this matter to our attention so effectively and will attempt to get a copy of the official notice and send it to you.

Sincerely,
Howard Coonley,
Director
Conservation Division

Six weeks after writing to President Franklin D. Roosevelt, Stoudt received a reply saying her idea for using duct tape was "of exceptional merit" and had been approved for use.

"I suggested," she wrote, "we use a strong cloth tape to close seams and make tab of same. It worked fine, I showed it to different government inspectors (and) they said it was all right, but I could never get them to change tape."

Appealing to FDR as a parent, she continued: "I have two sons out there somewhere, one in the Pacific Island the other one with the Atlantic Fleet. You have sons in the service also. We can't let them down by giving them a box of cartridges that takes a minute or more to open – the enemy taking their lives, that could have been saved. Had the box been taped with a strong cloth tape that can be opened in a split second. I didn't know who to write to, Mr. President, so I have written you hoping for your boys, my boys, and every man that uses the rifle grenade, that this package of rifle cartridges may be taped with the correct tape."

In closing, Stoudt wrote, "please Mr. President, do something about this at once, not tomorrow or soon, but now," she wrote, underlining the last word.

Six weeks passed. A letter from the War Production Board arrived. "Dear Mrs. Stoudt," it began "…you will be pleased to hear that we have received word from the Ordnance Department regarding your suggestions for changing the type of tape used in munition packaging… the change you have recommended has been approved with the comment that the idea is of exceptional merit."

No details exist of how quickly Stoudt's idea was implemented. The idea was sent to Johnson & Johnson, which was already making adhesive tapes for industrial and medical uses. They began producing a tape using Stoudt's idea and called it "duck tape." It was made of a cotton duck fabric sandwiched between a layer of adhesive and a coat of polyethylene. It was described as being so effective in keeping things dry that water would bead off it like water off a duck's back.

It's important to note that Stoudt did not *invent* duck tape, which would later be renamed "duct tape" after the war. Her genius was in seeing how a practical fix could avoid a potential loss of life.

One remarkable woman with a brilliantly simple idea, one compelling letter, one open-minded president helped change a military process, a decision that may have saved thousands of soldiers' lives.

Photo Credits

Activists

4	Opal Lee	Courtesy Opal Lee.
5	Opal Lee	© 2023 Associated Press.
6	Opal Lee	© 2023 Associated Press
7	Opal Lee	Jake May, photographer, Associated Press, 2018.
8	Dorothy Harrison Eustis	© 1933 Associated Press
10	Barbara Gittings	Kay Tobin, photographer, 1972. New York Public Library Digital Collections.
11	Barbara Gittings	Kay Tobin, photographer, 1972. New York Public Library Digital Collections.
12	Barbara Gittings	Kay Tobin, photographer, 1966. New York Public Library Digital Collections.
13	Barbara Gittings	Sander Dalhuisen, photographer. Pexels, 2019.
14	Mary Tape & Mamie Tape	Alamy
17	Mary Tape & Mamie Tape	Photographer unknown. Lantern slide. Collection of Oakland Museum of California.
18	Anna Jarvis	Photographer unknown. West Virginia and Regional History Center.

Bold Creatives

22	Ann Lowe	Moneta Sleet, Jr., photographer, Ebony magazine. Johnson Publishing Company Archive. Courtesy J. Paul Getty Trust and Smithsonian National Museum of African American History and Culture. Made possible by the Ford Foundation, J. Paul Getty Trust, John D. and Catherine T. MacArthur Foundation, The Andrew W. Mellon Foundation, and Smithsonian Institution.
23	Ann Lowe	Toni Frissell, photographer. Library of Congress.
24	Ann Lowe	Library of Congress.
25	Ann Lowe	Moneta Sleet, Jr., photographer, Ebony magazine. Johnson Publishing Company Archive. Courtesy J. Paul Getty Trust and Smithsonian National Museum of African American History and Culture. Made possible by the Ford Foundation, J. Paul Getty Trust, John D. and Catherine T. MacArthur Foundation, The Andrew W. Mellon Foundation, and Smithsonian Institution.
26	Emma Lazarus	T. Johnson and W. Kurtz, 1889.
27	Emma Lazarus	Catalogue of the Pedestal Fund Art Loan Exhibition. New York, National Academy of Design, 1881. p. Cover.
29	Emma Lazarus	Marianna, Pexels. pexels.com/@marianna-15577
30	Elizabeth Hobbs Keckley	Photographer unknown. Taken at Jefferson Fine Art Gallery, Richmond, VA. Lincoln Presidential Library.
31	Elizabeth Hobbs Keckley	Matthew Brady, photographer. Library of Congress.
32	Elizabeth Hobbs Keckley	Unidentified Artist, etching and engraving on paper, ca. 1868, National Portrait Gallery, Smithsonian Institution
33	Elizabeth Hobbs Keckley	Photographer unknown, National Museum of American History.
34	Ann Axtell Morris	Photographer Unknown. © Univ. of Colorado Museum of Natural History.
35	Ann Axtell Morris	Peabody Museum of Archaeology and Ethnology, Harvard University.
36	Ann Axtell Morris	Peabody Museum of Archaeology and Ethnology, Harvard University.
37	Ann Axtell Morris	Peabody Museum of Archaeology and Ethnology, Harvard University.
38	"Kitty" Black Perkins	Courtesy Mattel
39	"Kitty" Black Perkins	Courtesy Mattel
41	"Kitty" Black Perkins	Avril O'Reilly, photographer. Alamy

The Firsts

Scientists and Inventors

Women and War